Philip Morris over the years has supported numerous major exhibitions that embodied new and critical cultural insights into the history and character of the United States and the American people. It is impossible, I believe, to suggest another artist who portrayed our country during the twentieth century with greater realism and forthrightness than Edward Hopper.

The exhibition "Edward Hopper: Prints and Illustrations," which is associated with this publication, and which we cosponsor with the National Endowment for the Arts, deals with a relatively undocumented, yet important, phase of his life—and it should clarify our perceptions of one of our most influential artists. Moreover, in supporting this and the succeeding Hopper exhibition of paintings and drawings, we also hope to stimulate a closer examination of our American nature as well.

With these Hopper exhibitions and scholarly publications, the Whitney Museum of American Art marks the fiftieth anniversary of its founding. We salute the Whitney Museum on this grand occasion and, with our support, join in the celebration.

George Weissman
Chairman of the Board
Philip Morris Incorporated

EDWARD HOPPER

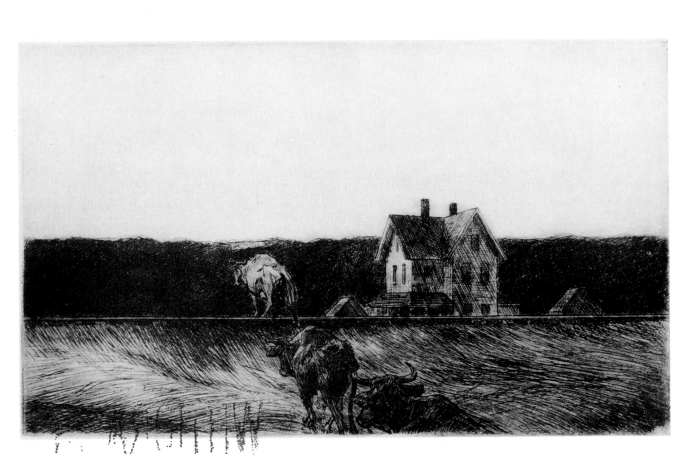

EDWARD HOPPER

THE COMPLETE PRINTS

GAIL LEVIN

W · W · NORTON & COMPANY · NEW YORK · LONDON

IN ASSOCIATION WITH THE

WHITNEY MUSEUM OF AMERICAN ART

This book and *Edward Hopper as Illustrator,* published simultaneously by W. W. Norton & Company in association with the Whitney Museum of American Art, accompany the exhibition "Edward Hopper: Prints and Illustrations" organized by the Whitney Museum and sponsored by Philip Morris Incorporated and the National Endowment for the Arts.

Dates of the exhibition

Whitney Museum of American Art, New York
September 27–December 9, 1979

Museum of Fine Arts, Boston
February 5–March 16, 1980

Georgia Museum of Art, Athens
March 30–May 11, 1980

Detroit Institute of Arts
June 10–July 20, 1980

Milwaukee Art Center
August 7–September 21, 1980

Seattle Art Museum
October 16–November 30, 1980

FRONTISPIECE: Pl. 69. *American Landscape,* 1920. Etching, $7\frac{1}{2} \times 12\frac{1}{2}$ inches. Whitney Museum of American Art, New York; Gift of Gertrude Vanderbilt Whitney 31.609.

BOOK DESIGN BY ANTONINA KRASS
LAYOUT BY BEN GAMIT
Typography by Fuller Typesetting of Lancaster
Printed by The Meridan Gravure Company
Bound by The Haddon Craftsmen

Library of Congress Cataloging in Publication Data
Hopper, Edward, 1882–1967.
Edward Hopper, the complete prints.
1. Hopper, Edward, 1882–1967—Catalogues. I. Levin, Gail II. Title.
NE539.H65A4 1979 769'.92'4 79–13567
ISBN 0–393–01275–1

1 2 3 4 5 6 7 8 9 10

CONTENTS

PREFACE

This volume is a prelude to the catalogue raisonné of Edward Hopper's prints which will be published together with three other volumes on his paintings, drawings, and illustrations. At that time a complete record of institutional holdings, states, publication, and exhibition history will be included.

For an exhibition at the Philadelphia Museum of Art and a publication of his prints in 1962, Hopper and his wife cooperated with Carl Zigrosser who compiled a catalogue raisonné of Hopper's known prints. It was not possible to list the prints chronologically because Hopper no longer remembered the dates he made them. Nor were there any records available of the early exhibitions where he showed his paintings or prints. Yet in the Hopper Bequest to the Whitney Museum were several prints not listed by Zigrosser, as well as plates without extant prints. There were also three drawings with inscriptions identifying them as sketches for plates where neither print nor plate is known to exist.

A search through the catalogues and reviews of early group exhibitions has turned up several, beginning in 1918, which included Hopper's prints. Some of the prints, including *Monhegan Boat* and *Cow and Rocks,* were clearly made earlier than Hopper indicated to Zigrosser, since they were exhibited in 1918. Several prints included in ex-

hibitions during 1918–20 are either lost or are now known by another name. An early ledger has come to light which identifies some of the previously unlisted plates for which only posthumous prints are known to exist. The records Hopper kept of his etchings are incomplete, as are most of his attempts at record keeping before his marriage in 1924 to the exacting Jo Nivison. Further information will surely come to light on the early exhibition history of his prints, possibly indicating additional revisions of dates. His notations do indicate that his prints, like his paintings, were often rejected from juried exhibitions. They were also sold by many dealers, often without specific exhibitions.

In addition to his complete known prints, this volume also includes all known preparatory drawings for prints as well as several closely related drawings. Possibly additional preparatory drawings will also come to light in the future.

In the process of compiling the catalogue raisonné, I have attempted to collect all of Hopper's correspondence. Either original manuscripts or copies of all the letters from the artist referred to in this volume are in the Hopper archives at the Whitney Museum of American Art.

I am deeply grateful to Tom Armstrong, Director of the Whitney Museum of American Art, for entrusting to me so important a project as the catalogue raisonné of Edward Hopper and for his encouragement and continuing support of this endeavor. I wish to thank the Andrew W. Mellon Foundation which has generously supported research for the catalogue raisonné of Hopper's work. I also appreciate the important support for the exhibition which accompanies this publication from both Philip Morris Incorporated and the National Endowment for the Arts.

Lloyd Goodrich, whose writings on Hopper as well as his unpublished notes from extensive interviews provide an important resource, has been a constant source of encouragement. I am grateful for the generous loan of Hopper's ledger books bequeathed to him. His early and lasting enthusiasm for Hopper's work, continuing Gertrude Vanderbilt Whitney's original commitment to this artist, resulted in the Hopper Bequest to the Whitney Museum. He first wrote about Hopper's work in an enthusiastic review for *The Arts* over fifty years ago.

Many dedicated members of the staff of the Whitney Museum, too numerous to list here, have made invaluable contributions to this project. Doris Palca has skillfully supervised the publication of this volume. Margaret Aspinwall, along with James Mairs of W. W. Norton and Company, has edited this manuscript, making valuable suggestions for which I am most appreciative. Anita Duquette facilitated the photography arrangements. Tom Hudspeth has also assisted me in organizing

the photographs and other innumerable details. I thank Terry Hubscher who typed this manuscript. I am also extremely grateful to the many volunteers who have worked on various aspects of the Hopper project: Julie Goodman, Dorian Rogers, Angela White, Nancy Shor, Lisa Frost, Ann Reynolds, and Noel Manfre.

I would also like to thank Kneeland McNulty and the entire staff of the Print Department at the Philadelphia Museum of Art. I also appreciate the efforts of the staff in the Department of Rights and Reproductions there.

This project could not have been properly realized without the posthumous printing of the plates in the Hopper Bequest to the Whitney Museum for which no print was known to exist. I am grateful to Steve Sholinsky for his conscientious effort: he has carefully printed them with the blackest ink, on the very white Umbria paper that Hopper said he preferred.

Additionally, I have had valuable conversations with John Clancy, Barbara Novak, and Brian O'Doherty, who knew the Hoppers well and who generously shared their reminiscences with me. I also wish to thank all those who through their personal recollections have helped me to know Hopper better. For information on Nyack and the Hopper family, I appreciate the help of Arthayer R. Sanborn, Maureen Gray, and Alan Gussow.

I would also like to express my appreciation to others who have helped me in important ways: Daniel Abadie, Milton Cederquist, Sylvan Cole, Seth and Sarah Glickenhaus, Lawrence A. Fleischman, Martin Gordon, Robert L. Mowery, Helen Farr Sloan, and Helen Tittle.

John I. H. Baur, Milton Brown, and Judith Goldman read this manuscript in early drafts and offered me valuable suggestions. I am very grateful for their interest and their insights. I would especially like to thank Jules Prown for his encouragement and for his invaluable support of this project.

For the content and conclusions of the book, I am, of course, responsible. I hope that the first publication of Hopper's complete prints and the accompanying analysis will add to the understanding of the art and development of Edward Hopper. They are a distinguished aspect of his complete oeuvre and deserve to be better known.

<div style="text-align: right">

Gail Levin
April 12, 1979

</div>

EDWARD HOPPER

INTRODUCTION

Although Edward Hopper is known primarily for his oils and water-colors, during his formative years from 1915 to 1923 he concentrated on printmaking, producing an outstanding group of etchings and dry-points. They are of sufficient quality to have assured him a place in American art history even had he not gone on to paint the pictures for which he is so deservedly famous.

After completing his studies in New York at the Correspondence School of Illustrating (1899–1900) and the New York School of Art (1900–06), Hopper, then twenty-four years old, left for Paris in October 1906 (Fig. 1). He did not return to New York until the end of August 1907, and he traveled again to Europe in 1909 and in 1910. After his return from this last trip until his successful exhibition of recent watercolors at the Frank K. M. Rehn Gallery in New York in 1924, Hopper supported himself through his work as a commercial artist and illustrator.[1]

He experienced frustration at having to do commercial work when he wanted to be a serious artist. Although he was able to exhibit his paintings in group shows during the 1910s, he sold only one, *Sailing*, an oil painting of 1911, which was purchased from the Armory Show in 1913 for $250 (Fig. 2). He continued to exhibit his paintings but did not sell another until the Brooklyn Museum purchased his water-

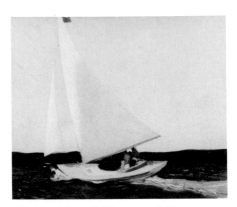

Fig. 2. Edward Hopper, *Sailing*, 1911. Oil on canvas, 24 × 29 inches. Museum of Art, Carnegie Institute, Pittsburgh.

Fig. 1. Edward Hopper in Paris, 1907.

Fig. 3. Edward Hopper, *The Mansard Roof*, 1923. Watercolor, 14 × 20 inches. The Brooklyn Museum, New York. This was Hopper's first painting purchased by a museum when it sold for $100 in 1923.

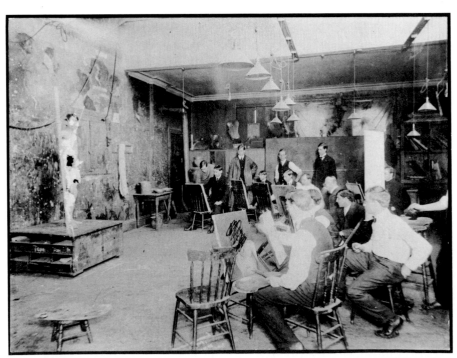

Fig. 4. Robert Henri's class at the New York School of Art, c. 1903–04. Hopper is third from the left. To his left stand Rockwell Kent and Arthur Cederquist. George Bellows leans over the first easel on the left.

color *The Mansard Roof* in 1923 (Fig. 3). After he began to etch, he found that his prints were more readily accepted for exhibition and that they sold well at the modest prices he asked.

Contrary to what has been written, he did not withdraw and give up painting during these years.[2] Instead he painted on summer trips to Massachusetts and Maine, and experimented in his development as an artist by learning an unfamiliar medium. "Etching? I don't know why I started. I wanted to etch, that's all."[3]

In his formal art schooling Hopper did not study printmaking. He studied life drawing and painting at the New York School of Art with William Merritt Chase, Robert Henri, and Kenneth Hayes Miller (Fig. 4), and his classmates included Patrick Henry Bruce, George Bellows, Arthur Cederquist, Glenn O. Coleman, Guy Pène du Bois, Arnold Friedman, Walter Pach, and Walter Tittle.

By 1915, Hopper had become acquainted with Martin Lewis, an Australian artist one year his senior who first arrived in New York in 1900. Like Hopper, Lewis not only painted but also worked in commercial art and illustration. Lewis had begun to etch, often depicting scenes of New York City, and gave Hopper some technical advice on etching, including where to purchase the necessary materials. With this initial encouragement, Hopper made his first tentative attempts in a medium that he would soon master.

Lewis, who pursued printmaking for the rest of his career, became interested in larger works which combined elaborate technical variations with etching, while Hopper always worked simply in etching or drypoint without aquatint, mezzotint, or other processes.[4] Lewis's earliest extant prints, which date from 1915, are the closest in feeling to Hopper's etchings both in subject matter and in their relatively simple and direct execution. Lewis's *Smoke Pillar, Weehawken* (Fig. 5) recalls Hopper's own fascination with trains in his Paris drawing *The Railroad* of 1906/7 or 1909 (Fig. 6). Hopper etched *Somewhere in France* during 1915–18, *Train and Bathers* in 1920, and *The Locomotive* in 1923 (Pls. 49, 74, 100). Lewis's use of an oblique angle into space is related to that often employed by Hopper; similar buildings, trains, and railroad tracks frequently appear in Hopper's work. Hopper never dramatized puffs of smoke to the extent that Lewis did, however, nor did he ever employ such a vertical format with such a vast amount of sky. *Rooftops, Manhattan* (Fig. 7), produced by Lewis in 1918, recalls Hopper's *St. Nicholas Terrace* and *On My Roof*, both 1915–18 (Pls. 9, 26). Lewis depicted a typical city view with night windows, water tanks, and chimneys, just as Hopper was to do many times in both prints and paintings.

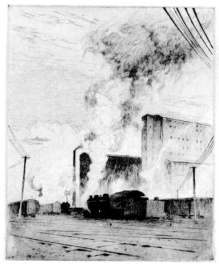

Fig. 5. Martin Lewis, *Smoke Pillar, Weehawken*, 1915. Drypoint, etching, and aquatint, 6¾ × 13⅞ inches. Collection of Patricia Lewis; photo courtesy Kennedy Galleries, Inc., New York.

Fig. 6. Edward Hopper, *The Railroad*, 1906/7 or 1909. Charcoal on paper, 17¾ x 14⅞ inches. Whitney Museum of American Art, New York; Bequest of Josephine N. Hopper 70.1049.

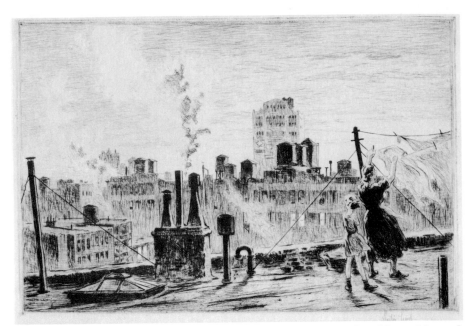

Fig. 7. Martin Lewis, *Rooftops, Manhattan*, 1918. Drypoint and etching with sand-paper ground, 7 × 10⅜ inches. Collection of Paul McCarron.

As Lewis had taught etching technique to him, Hopper in turn taught artist, illustrator, and former classmate Walter Tittle. Tittle went on to make his reputation as a portraitist and became known for his portraits in drypoint. Hopper and Tittle were neighbors at 3 Washington Square North, from January 1914 when Hopper rented the studio adjoining Tittle's until Tittle moved out over thirteen years later (Figs. 8, 9; Pls. 53, 54, 55). Tittle helped Hopper find illustrating commissions during these years and Hopper persuaded him to take up etching:

> Being swamped with commissions, my good intentions needed Edward Hopper's active aid . . . before I was launched into the endless beguiling and difficult intricacies of this exacting art. . . . My neighbor was busy messing about with bottles of acid, porcelain trays, balls of ground, etc., with an eagerness born of new interest. Occasionally he would show me his experiments, and use me as a model for his plates. He urged me to try this medium, pursuing his propaganda in this direction with remarkable persistence. He adopted a cookoo-clock [*sic*] technique, popping his head through our connecting door with monotoonously repeated advice:
>
> "Make an etching, make an etching," and so on indefinitely. The door would slam to escape a missile or bar a rush, then open again:
>
> "Buy a copper plate, buy a plate, buy a plate!" As drops of water wear away stone, he forced me into an activity that I had really craved for a long time.[5]

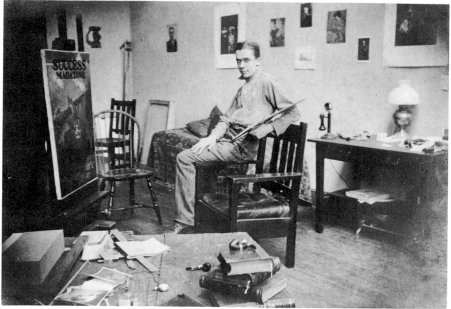

Fig. 8. Photograph of Walter Tittle in his studio at 3 Washington Square North, c. 1915. Collection of Wittenberg University Library, Springfield, Ohio.

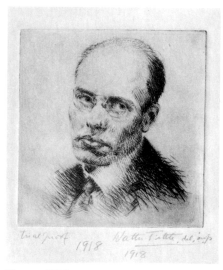

Fig. 9. Walter Tittle, *Edward Hopper*, 1918. Drypoint, 3½ × 3⅞ inches. Private collection.

In these early years of struggle to support himself and to find his best means of expression, Hopper taught himself to be such an accomplished etcher that his works have come to be considered among the finest examples of American printmaking. Except for his award for a war effort poster in 1918 (Fig. 10), his first public recognition through prizes and critical articles in art journals was for his prints.[6] He received first awards in 1923 for his etching *East Side Interior* (Pl. 85): the Logan Prize from the Chicago Society of Etchers and the William Alanson Bryan Prize for the best American print at the Fourth International Print Makers Exhibition in Los Angeles. Hopper first exhibited his etchings in a group exhibition at the MacDowell Club in 1918. Among the numerous exhibitions that included Hopper's etchings was the First International Exhibition of Etching, organized by the Brooklyn Society of Etchers in April 1922 at the Anderson Galleries in New York. This entry was *Night Shadows* (Pl. 82); the entry of fellow artist William V. Graff, whom Hopper had earlier depicted in several drawings, an etching, and a drypoint (Pls. 39, 40, 41, 42, 43, 44), was a portrait of Hopper (Fig. 11).

In 1927, when Hopper had virtually given up printmaking—he produced only two more, drypoints, *The Balcony* and *Portrait of Jo* (Pls. 108, 109)—he wrote an article for *The Arts* about the graphic work of John Sloan. His words about Sloan's work convey the goals he seems to have sought in his own:

Sloan's design is the simple and unobstrusive tool of his visual reaction. It attempts tenaciously and ever the surprise and unbalance of nature, as did that of Degas. It composes by mass rather than perimeter and never attempts to shock by the bizarre. The very direct method of his best etchings suggests the honest simplicity of means of the early Dutch and Flemish masters, akin to line-engraving at times, as is also the simple and clean wipe of the plates in their printing. Values are achieved with an economy of line and open cross-hatching where necessary.

Hopper went on to say that Sloan "is the inheritor of the tradition of Daumier, Gavarni and Manet and that great movement in French art to which they belong." He also paid tribute to Robert Henri, his enthusiastic and powerful teacher, for communicating the importance of this French art to his students and as a leader in the struggle to make "the art of this country a living expression of its character and its people." [7]

Fig. 11. William V. Graff, *Portrait of Edward Hopper*, c. 1918. Drypoint, 5⅞ × 5 inches. Whitney Museum of American Art, New York; Bequest of Josephine N. Hopper 70.1686.

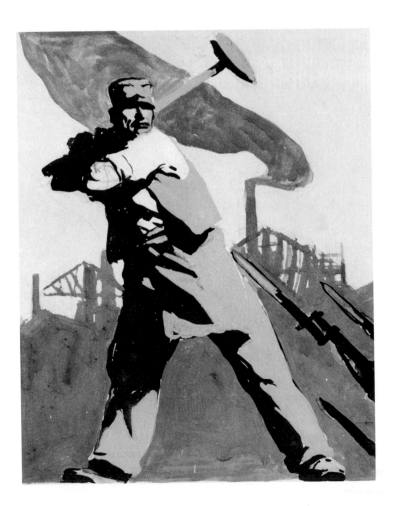

Fig. 10. Edward Hopper, study for poster *Smash the Hun*, 1918. Gouache on illustration board, 9½ × 6⅜ inches. The Charles Rand Penney Collection.

HOPPER'S METHODS

The first prints that Hopper is known to have made were monotypes, of which he kept five examples (Pls. 1, 2, 3, 4, 5). The monotype, produced by painting, rubbing, or wiping a design made of a slow-drying oil paint or ink directly on a plate and printing the image before the plate dries, can be viewed as an intermediate stage between painting and printmaking. The monotype process offered Hopper a valuable experience—a chance to explore the reaction of different pigments pressed in direct contact with various kinds of paper. It was for him a prelude to printmaking. He printed his monotypes on scraps of paper and envelopes postmarked 1902 (Fig. 12), indicating he made them while he was a student at the New York School of Art.

Perhaps because Robert Henri, his favorite teacher at the school, was personally very involved with portraiture and encouraged his students to work from life, Hopper's monotypes are all portraits. (Another of his teachers, William Chase, also made monotype portraits.) Henri himself experimented with etching under John Sloan's guidance in 1904, but he produced only one print, *Street Scene in Paris*.[8] Henri also made monotypes, but several years later than Hopper had. Nonetheless, he taught his students to seek a personal style; he wanted them to be free to experiment.

In 1915, after Hopper got technical advice on etching from Martin

Lewis, he bought supplies and began to etch. He employed the traditional means of etching: scratching his design with a needle into an acid-resistant ground covering a metal plate and then immersing the plate in acid so that the exposed lines would be "bitten" and thus hold ink for printing. He also taught himself to make drypoints, a direct and simple process where the artist scratches the image into a metal plate with a steel needle, leaving a furrow bordered by a curl of metal or burr which catches ink during printing and produces a characteristic velvety line. Because the burr is easily worn down in the process of inking, wiping, and printing, drypoint plates are limited to smaller editions of prints than is possible with etching.

While several early works were on zinc, Hopper used copper plates for most of his etchings, and he did most of his drypoints on zinc plates with the rest on copper. He originally did his own printing, with the notable exception of *Night Shadows* (Pl. 82).[9] Walter Tittle noted in his unpublished autobiography that Hopper obtained his press from the New York Banknote Company. It remained in his studio all his life, serving as a hat rack after he ceased making prints (Fig. 13). He did not number his prints but produced them as needed. One hundred examples was his limit for each print, except *Night Shadows*, and he attempted to keep track of each in ledger books, one of which survives today. Before his marriage in 1924, however, his record keep-

Fig. 12. Envelopes postmarked 1902 which are the reverse sides of two of Hopper's monotypes.

ing was erratic at best, so that accurate records on the prints do not exist. In addition, he occasionally referred to a print by more than one name.

He preferred his plates deeply bitten, well inked, and fairly clean-wiped, printing very black ink on very white paper. Some etchings such as *Cow and Rocks, Les Poilus, The Monhegan Boat,* and *Train and Bathers* were printed in brownish or greenish ink, although later examples of these were often in black ink on white paper. Hopper felt that

> The best prints were done on an Italian paper called "Umbria" and was the whitest paper I could get. The ink was an intense black that I sent for to Kimber in London, as I could not get an intense enough black here. I had heard so much of the beauty of old paper that I tried some 18th Century ledger paper, but it did not give me the contrast and brilliance that I wished, and I did not use it.[10]

Included in the Hopper Bequest to the Whitney Museum were plates for fifty-five of Hopper's known prints as well as thirteen plates for which no print was known to exist.[11] Only a few of these were actually canceled by the artist. One shows a seated self-portrait above which Hopper later sketched a man's head and the back of a female nude (Pl. 55). Two other canceled plates show a city street scene and a sailboat (Pls. 6, 93). A preparatory drawing exists for the sailboat (Pl. 94), but the plate itself became a veritable doodle pad with seven heads and a full-length standing figure haphazardly etched on the sky area around the sailboat. This sailboat may have preceded *The Henry Ford* (Pl. 95).

Hopper left no notes of his working procedure, and the known group of preparatory drawings is undoubtedly incomplete. It seems from the existing drawings, however, that many of the early etchings were executed directly on the plate. Many of the subjects in the early prints were based on memory or imagination, not on sketches recently made for etchings. These include recollections of France in prints like *Street in Paris, Les Poilus,* or *Evening, the Seine;* and *Don Quixote,* the only theme from literature (Pls. 8, 28, 13, 12). He also etched *The Bull Fight,* perhaps in response to his expressed admiration for Goya,[12] but recalling as well the lasting impression made by the bullfight he had attended in Spain in 1910, seven years earlier (Pl. 50). He had written to his sister:

> I went to a bull fight last Sunday and found it much worse than I thought it would be. The killing of the horse by the bull is very

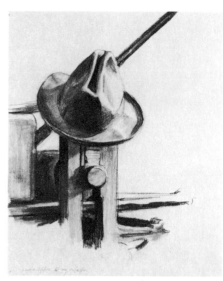

Fig. 13. Edward Hopper, *Etching Press with the Artist's Hat,* after 1924. Conte on paper, 11⅛ × 15¼ inches. Whitney Museum of American Art, New York; Bequest of Josephine N. Hopper 70.344.

horrible, much more so as they have no chance to escape and are ridden up to the bull to be butchered. It is not what I would call an exciting sport, merely brutal and sickening. The entry of the bull into the ring however is very beautiful, his surprise and the first charges he makes are very pretty.[13]

The later etchings were often carefully worked out in preparatory drawings. Even so, Hopper continued to adjust his compositions, adding and subtracting details as he took them from drawing to etching. In *House on a Hill* (Pls. 75, 76), for example, Hopper added a tiny figure in the background and wind-blown curtains in the first-floor window to the etching that are not visible in the drawing. He left out of the etching the horsewhip held by the man driving the buggy, and he made the highlights more subtle.

In *People in a Park* (Pls. 62, 63), the figure on the far left is left ill-defined in the etching, having lost some of the definition of shadows and wrinkles present in the drawing. Even much of the background foliage is now omitted. Yet, in contrast, the child standing beside the carriage and the three figures at the distant end of the bench and the empty bench are now more closely visible. In *The Lighthouse* (Pls. 98, 99), particularly subtle changes have taken place between the drawing and the etching. The rock in the foreground has weathered to a more rounded shape, the lighthouse tower has less shading and various rocky forms have more definition, and the artist sitting in the foreground sketching is more precisely delineated.

The evolution of *Evening Wind* (Pls. 77, 78) to etching from preparatory drawing has meant a sharper focus on the nude woman in the foreground through elimination of the distracting definition of background details. The two picture frames in the drawing, for example, are much less noticeable in the etching. The woman's hair and the bed coverlets are given extra highlights which help to hold attention there. Similarly, focus is realigned in *The Railroad* (Pls. 87, 88): in the drawing the man's face is in shadow while his legs are clearly visible, whereas in the etching the man's legs are lost in shadow but his facial features are more clearly defined, as are details among the foliage and electric poles.

Hopper also reworked a few of his plates. From two to as many as eight states of these prints are known to exist. Often the changes are rather slight from one state to the next, but the total cumulative changes are considerable. For example, *House on the Hill* or *The Buggy* underwent seven states: the final state has much darker, more defined foliage, and more texture and shading on the rooftops (Fig. 14,

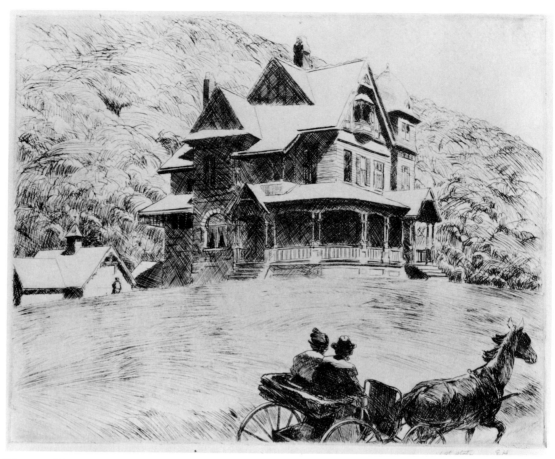

Fig. 14. Edward Hopper, *House on a Hill* or *The Buggy*, 1920. Etching, first state, 8 × 10 inches. Philadelphia Museum of Art: Purchased: The Harrison Fund.

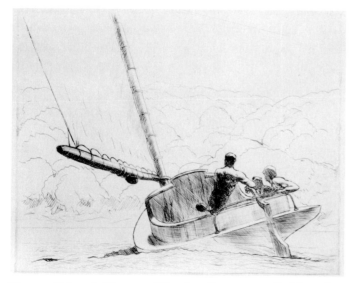

Fig. 15. Edward Hopper, *The Cat Boat*, 1922. Etching, first state, 8 × 10 inches. Philadelphia Museum of Art: Purchased: The Harrison Fund.

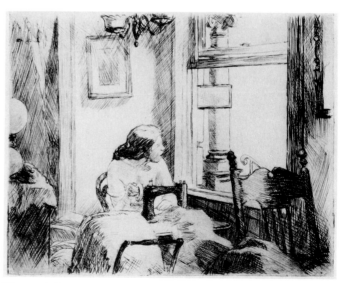

Fig. 16. Edward Hopper, *East Side Interior*, 1922. Etching, first state, 8 × 10 inches. Philadelphia Museum of Art: Purchased: The Harrison Fund.

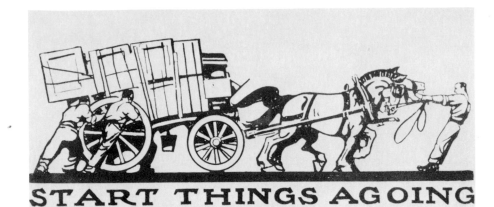

Fig. 17. Edward Hopper, "Start Things Agoing," proof, commercial illustration, c. 1910–12. Publication unknown.

Fig. 18. Edward Hopper, "Variety Is The Spice Of Life," proof, commercial illustration for Fashion Clothes, c. 1911–12. Publication unknown.

Pl. 75). The first state of *The Cat Boat* is dramatically different from the final state. The foliage is only lightly sketched, the water lacks definition, and parts of the rigging are omitted (Fig. 15, Pl. 83). The first state of *East Side Interior* lacks the dramatic chiaroscuro effect of the final state (Fig. 16, Pl. 85). Some forms, such as the bone structure of the woman's face, are not yet fully defined; others will become increasingly obscured by the shadows created by added lines. In various states, Hopper took the opportunity to experiment with an image before pushing it toward a more distinct definition.

Hopper experimented with linoleum cuts for Christmas cards in the years soon after his marriage (Pls. 105, 106, 107). These are characteristically printed in black ink on white paper and their bold images recall emblematic designs in some of his earliest illustrations (Figs. 17, 18).

Hopper made his last etchings in 1923. By that time he was painting in watercolor more and more regularly, and his watercolors and oils were now being exhibited as often as his etchings. With his marriage to Josephine Verstille Nivison in 1924 and his successful exhibition of watercolors at the Rehn Gallery in the same year, what we may consider his formative period came to an end. In 1925 he drew his last illustrations (published in *Scribner's* magazine in 1927), and in 1928 he made his very last prints, the drypoints *The Balcony* and *Portrait of Jo* (Pls. 108, 109). In *The Balcony*, which has also been called *The Movies,* Hopper conveys the boredom of waiting, one of his favorite themes. The lighting is the harsh glow of electric lamps. The theater has a steeply inclined balcony, a familiar balustrade, and empty seats remaining. We, like these two figures, are waiting for the action to begin. One man, however, leaves the balcony from the doorway just below. Hopper is in superb command of the line here with which he so carefully renders light and dark, form and space.

THE PRINTS

The impact of Hopper's European experience is still readily apparent in his prints although he did not begin to etch until 1915, five years after his last trip abroad. "It seemed awfully crude and raw here when I got back. It took me ten years to get over Europe." [14] During this time Hopper was of necessity preoccupied with supporting himself by illustrating and living frugally.

In contrast to his illustrations, prepared for editors concerned with a popular audience, his etchings were an extremely personal means of artistic expression.[15] They provided an outlet for the nostalgia he felt for his Paris sojourn. He savored this experience, and although he never again traveled abroad, his interest in French art and culture remained with him for the rest of his life.[16]

For Hopper, Paris represented both intellectual and artistic attainment as well as romance. Just how much France represented a romantic ideal—in fact a symbol of longing—can be seen in the Christmas card he designed for Jo in 1923 before their marriage the following July (Fig. 19). He depicted them together, reclining before an open window, with the full moon and the spires of Notre Dame in full view in the Paris night. Hopper had not been in Paris for thirteen years and he and Jo had never been there together. Beneath this picture, next to the inscription "à Mlle. Jo. / Noël 1923," he included six lines on evening

from "La Lune Blanche" by Paul Verlaine, the same six lines he quoted in an interview nearly forty years later.[17] In a cartoon he made for Jo, entitled *Le rève de Josie,* he caricatured himself as a tattered, professorial, monocled intellectual, his wife's dream (Fig. 20). Of the five books in his basket, two are in French, Proust's *Du Cote de Chez Swan* and *Poèsie de Paul Verlaine.*

Walter Tittle recalled that Hopper was deeply involved with his experience in France during the period he began to etch:

> My neighbor was groping to find himself. Around his studio stood some canvases that he had produced in his Paris days, after our short association in the Chase–Henri school. He wanted to go on from there, but for a considerable period his principal product consisted of occasional caricatures in a style smacking of both Degas and Forain, and drawn from memories of his beloved Paris [Fig. 21].[18]

Hopper gave four of his prints French titles: *Les Poilus, Les Deux Pigeons, La Barrière,* and *Aux Fortifications* (Pls. 28, 71, 29, 89). The latter two show people relaxing on an embankment, the old ramparts encircling Paris where the working classes met to socialize. He found in the heights of Belleville, located in the northeast of Paris overlooking the old city, a colorful area that became for him the French equivalent

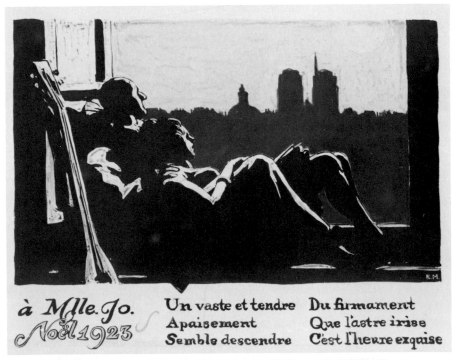

Fig. 19. Edward Hopper, *Christmas Card for Jo Nivison,* 1923. Gouache on paper, 7 × 8⅝ inches. Private collection.

to New York's lower-class districts captured by John Sloan, George Bellows, and others in the circle of his teacher Henri. In *La Barrière* we see not only the rooftops of old Paris in the distance, but the debris of discarded wine bottles. Here and in *Aux Fortifications* he has recorded the picturesque dress of the workers, the soldiers, and the women with their elaborate topknot coiffures.

All four of these etchings have in common his fascination with the interaction of French men and women. In *Les Poilus* three French soldiers dramatically confront a local woman clad in wooden shoes before a rural house. In *La Barrière* a woman flanked by two men stands staring toward the skyline with a near-defiant posture. *Les Deux Pigeons* is certainly the most overtly sensuous subject he ever depicted. The two pigeons are the couple embracing and kissing, oblivious to the waiter and the two men seated next to them in the open-air cafe. Here, set in a terrace cafe overlooking a river, he has conveyed his most romantic recollection of France and its charm. Indeed, he has transformed the Impressionists' celebrated cafe scenes into a picture of much greater intimacy—the fleeting moment in the drama of human emotion. There is a psychological intensity that sets Hopper's scene apart from some of the well-known Impressionist paintings such as Degas' *L'Absinthe* with its somber staged mood, or the lighter, more gleeful *The Luncheon of the Boating Party* by Renoir (Fig. 22). In other prints the subject matter is also clearly French: [*Paris Street Scene with Carriage*], *Street in Paris, Evening, the Seine,* [*Cafe*], *Somewhere in France,* all of 1915–18, and *Train and Bathers* of 1920 (Pls. 6, 8, 13, 48, 49). This latter etching, with its two nude bathers hiding behind bushes as a train, a French locomotive, passes over a bridge, provoked Martin Lewis to ask Hopper why he depicted a French locomotive when the American ones were so much more interesting to draw.[19]

Although it persisted longest in his etchings, Hopper gradually suppressed his nostalgia for France, and with his first one-man exhibition at the Frank K. M. Rehn Gallery in 1924, dropped French imagery entirely. He did not forget his love of French art and culture which remained an important influence throughout his life, but overt references were now reserved for intimate communications with his wife.

The adverse criticism which *Soir Bleu* (Fig. 23), a major painting of about 1914, received when he showed it in a group exhibition at the MacDowell Club of New York during February 11–21, 1915, began a gradually developing consciousness that "now or in the near future American art should be weaned from its French mother." [20] In contrast, *New York Corner* of 1913, a small canvas exhibited in the same show, was praised as "a perfect visualization of New York atmosphere" (Fig. 24).[21]

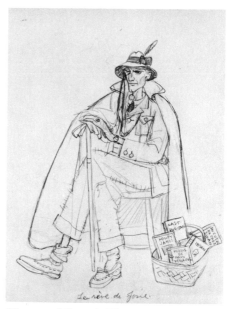

Fig. 20. Edward Hopper, *Le rêve de Josie*, c. 1924–30. Pencil on paper, 11 × 8½ inches. Private collection.

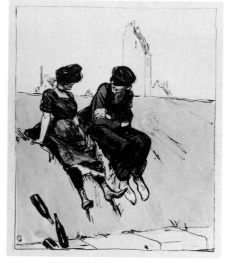

Fig. 21. Edward Hopper, *French Couple on Embankment*, 1906–14. Watercolor, ink, and conte on illustration board, 18⅞ × 15 inches. Whitney Museum of American Art, New York; Bequest of Josephine N. Hopper 70.1343.

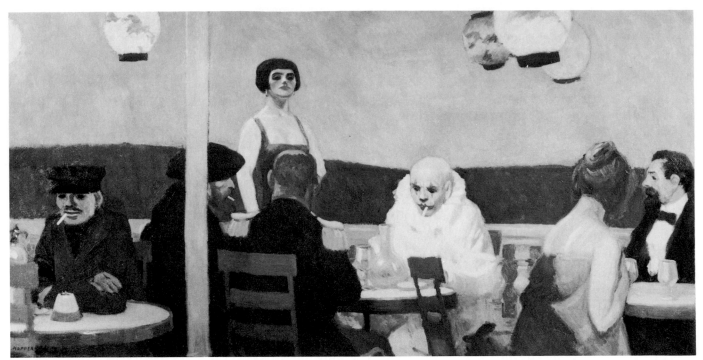

Fig. 23. Edward Hopper, *Soir Bleu,* c. 1914. Oil on canvas, 37 × 72 inches. Whitney Museum of American Art, New York; Bequest of Josephine N. Hopper 70.1208.

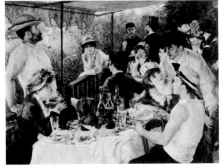

Fig. 22. Pierre Auguste Renoir, *Luncheon of the Boating Party,* 1881. Oil on canvas, 51 × 68 inches. The Phillips Collection, Washington, D.C.

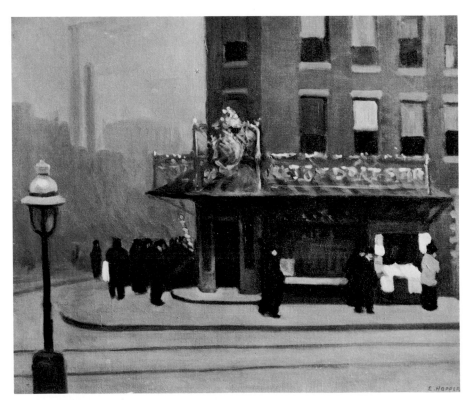

Fig. 24. Edward Hopper, *New York Corner* or [*Corner Saloon*], 1913. Oil on canvas, 24 × 29 inches. The Museum of Modern Art, New York; Abby Aldrich Rockefeller Fund.

Besides the romantic view Hopper held of France, his Christmas card for Jo also represents his choice of the window as an important symbol which recurs in his etchings and in later paintings. The tension between the interior and the exterior is already a preoccupation in his etching *From My Window* of 1915–18 (Pl. 14), and it would become even more important in subsequent work. His teacher Robert Henri had taught his students that "The look of a wall or a window is a look into time and space. Windows are symbols. They are openings in. The wall carries its history. What we seek is not the moment alone." [22]

In choosing the theme of a lone woman in an interior before a window as in nineteenth-century romanticism, Hopper uses the window as a symbol of the expansive world beyond the cramped interior.[23] In the etchings this theme is explored in *The Bay Window, Nude in a Chair, The Open Window, Evening Wind,* and *East Side Interior* (Pls. 10, 21, 24, 77, 85).

Although he did not wish to make political or social statements, a sense of loneliness, sometimes even boredom, is communicated in these works. The psychological subtleties were probably intentional, although Hopper once said:

> Just to paint a representation or design is not hard, but to express a thought in painting is. Thought is fluid. What you put on canvas is concrete, and it tends to direct the thought. The more you put on canvas the more you lose control of the thought. I've never been able to paint what I set out to paint.

To the numerous critical discussions of the theme of loneliness in his work,[24] Hopper answered:

> The loneliness thing is overdone. It formulates something you don't want formulated. Renoir says it well: "The most important element in a picture cannot be defined" . . . cannot be explained, perhaps, is better.[25]

The solitary woman before a window in an urban interior is also a much-repeated theme in the work of Edgar Degas which Hopper knew well and admired.[26] In several prints Hopper used curtains blowing at the window to set up a dramatic contrast between the contemplative mood of the solitary interior and the rest of the world beyond (Pls. 21, 77). *Nude in a Chair,* an early drypoint of 1915–18, anticipated *Evening Wind* of 1921, but only in a rather tentative way. He had already presented the female figure nude poised as though about to

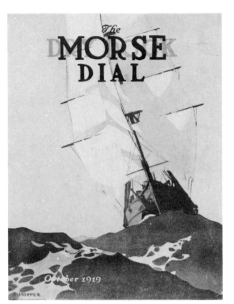

Fig. 26. Edward Hopper, *The Morse Dry Dock Dial*, 2 (October 1919), cover.

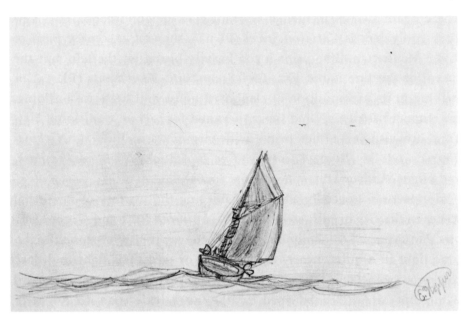

Fig. 25. Edward Hopper, [*Sailing*], c. 1896. Pencil on paper, 5 × 8 inches. Whitney Museum of American Art, New York; Bequest of Josephine N. Hopper 70.1605.100.

themes are related both to earlier drawings and paintings dating back to his childhood in Nyack and to the illustrations that he produced for magazines during this period (Figs. 25, 26).

Hopper's long fascination with trains resulted in the etchings *Somewhere in France, Train and Bathers, The Conductor, The Railroad, The Locomotive,* and *Railroad Crossing* (Pls. 49, 74, 62, 87, 100, 103). In its subject and formal arrangement *The Locomotive* recalls several drawings made in France either in 1906/7 or 1909 (Figs. 6, 27; Pl. 101). The dark shadow of the opening under the curving bridge and the structure itself appear in both drawings and the etching. In the drawing *The Railroad,* the train is at an angle that seems exactly reversed in *The Locomotive,* as though Hopper worked from the image of that early drawing.

Hopper's fascination with trains is also related both to the drawings and paintings of his formative years and to illustrations that he produced for the *Wells Fargo Messenger* and its successor *The Express Messenger* (Figs. 28, 29). From the time he began to commute to New York City to attend classes in the fall of 1899, trains became a very familiar aspect of his life. In the years just after he returned from France in 1910, he continued to commute daily to work either in an advertising agency or in his own studio. Trains and the views from them remained important themes throughout his mature career.

Besides the French subjects, another aspect of Hopper's prints that

practically disappeared from his art after 1924 was portraiture. His earliest prints, five monotypes, are all human heads (Pls. 1–5). He also did portraits in etching and drypoint of fellow artists William Graff, Arthur Cederquist, and Walter Tittle (Fig. 30; Pls. 39, 43, 45, 53, 55). This interest in artists and their activity, an age-old concern, is seen in *The Model* and *The Painter* as well as in the three self-portraits in which Hopper captured similar moments of the artist's concentration (Pls. 20, 27, 58, 59, 67). Two of these prints were apparently unpublished (Pls. 58, 59), and one of the plates is canceled by other sketches. The third, which was published, is a drypoint. In 1960, when Carl Zigrosser sent Hopper a photograph of it, he responded that he had forgotten having made it and added, "The portrait is no doubt me in one of my more brutal aspects." [27] Only three self-portraits survive from Hopper's maturity, but during his formative years the introspective

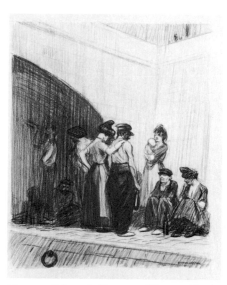

Fig. 27. Edward Hopper, *Figures Under a Bridge in Paris,* 1906/7 or 1909. Conté and wash on illustration board, 22⅛ × 15⅛ inches. Whitney Museum of American Art, New York; Bequest of Josephine N. Hopper 70.1339.

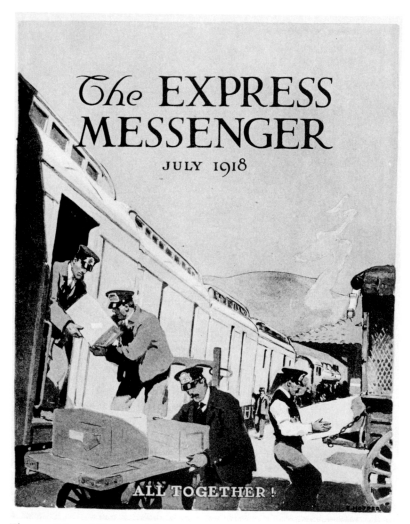

Fig. 29. Edward Hopper, *The Express Messenger,* July 1918, cover.

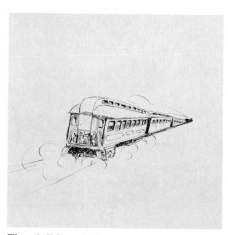

Fig. 28. Edward Hopper, [*Moving Train*], c. 1900. Pen and ink on paper, 4 × 5 inches. Whitney Museum of American Art, New York; Bequest of Josephine N. Hopper 70.1561.94.

Fig. 30. Arthur Cederquist.

young man frequently sketched and painted his own portrait. There is, finally, a drypoint *Portrait of Jo Hopper* (Pl. 109) which he made in 1928. This, his last print, along with his earlier portraits of his friends and his self-portraits, establishes his sensitive ability to capture his subjects in a contemplative mood.

Edward and Jo Hopper, Cape Elizabeth, Maine, 1927. Photograph by Soichi Sunami.

FROM PRINTS TO PAINTINGS

From the beginning Hopper viewed himself as a painter, not as a printmaker or an illustrator. However, during these early years his etchings brought his inclusion in numerous exhibitions, and their sale bolstered his morale and his ability to support himself by his art. Even the juries at the National Academy of Design, that conservative institution which repeatedly rejected Hopper's paintings, recognized the masterly draftsmanship of his prints and regularly included them in exhibitions. Hopper himself later felt "After I took up etching, my painting seemed to crystalize." [28]

Among his contemporaries, Hopper seems to have identified most closely with John Sloan who, like himself, had out of necessity worked as an illustrator at the beginning of his career. In 1927, Hopper wrote: "This hard early training has given to Sloan a facility and a power of invention that the pure painter seldom achieves." [29] He particularly admired the paintings and prints produced just after Sloan's arrival in New York in 1904, exempting from his enthusiasm only "one or two of the large portrait etchings done without much show of interest." [30] Hopper had found inspiration in Sloan's response to his New York environment: "Sloan not having been abroad, has seen these things with a truer and fresher eye than most. . . ." [31]

Above all, it was Sloan's choice of subject matter that made an im-

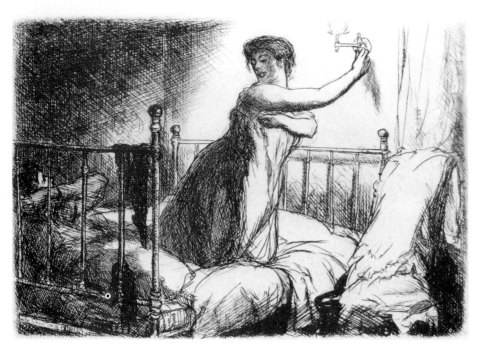

Fig. 31. John Sloan, *Turning Out the Light,* 1905. Etching, 9½ × 12⅝ inches. Whitney Museum of American Art, New York; Gift of Gertrude Vanderbilt Whitney 31.821.

Fig. 33. Charles Meryon, *La Rue des Mauvais Garçons,* 1854. Etching, 5 × 3⅞ inches. National Gallery of Art, Washington, D.C.; Rosenwald Collection.

Fig. 34. Charles Meryon, *La Morgue,* 1854. Etching, 9¹⁄₁₆ × 8⅛ inches. National Gallery of Art, Washington, D.C.; Rosenwald Collection.

pression on Hopper during his formative years. Among the subjects that appeared first in Sloan's work and subsequently in Hopper's prints are a woman in an interior by a window, city rooftops, urban street scenes, city parks, cafes, and the movies. Most of these themes marked a shift by Hopper away from his interest in French subjects. Hopper's *Evening Wind* is related in spirit to Sloan's etching *Turning Out the Light* made sixteen years earlier in 1905 (Pl. 77; Fig. 31). Sloan's print was rejected in 1906 by the committee on etchings of the American Water Color Society as too vulgar to be exhibited. Like Sloan, Hopper pursued sensuality in his etching and dramatized the situation through the manipulation of light and shadow. He also depicted views of city rooftops and the skyline in etchings and drypoints: *On My Roof, From My Window, St. Nicholas Terrace,* and *House Tops* (Pls. 26, 14, 9, 79). This, too, was a frequent subject in Sloan's earlier etchings such as *Roofs, Summer Night* of 1906, *Night Windows* of 1910, and *Love on the Roof* of 1914 (Fig. 32).

Charles Meryon, the nineteenth-century French etcher who produced enchanting views of Paris, is the only artist known primarily as a print-maker whom Hopper mentioned repeatedly throughout his life as one of the artists he most admired. At different times, he singled out Meryon's *Rue de la Tixeranderie* [32] and *Street of the Weavers* as particular etchings he admired. He remarked of the latter, "Marvelous rendition of sunlight. To me. Romantic sunlight." [33] In Meryon's etchings he found a fascination with architecture and light that matched his own, as well as the suggestion of the expressive possibilities of city views.

Meryon's inspiration is perhaps reflected in *The Lonely House,* Hopper's etching of 1923 (Pl. 102). The imposing structure with its darkened entrance and windows recalls Meryon's *La Rue des Mauvais Garçons* (Fig. 33). Even Hopper's device of cutting off the top of the building, the dwarfed human figures, and the selective use of texture is similar to Meryon's work. Hopper's *House at Tarrytown,* a drypoint of 1923, with tall smokestacks on the right and a play of light and shadow over architecture, is also similar to etchings by Meryon such as *La Morgue* (Fig. 34). Hopper's uncharacteristic inclusion of fantastic oversize birds for his greeting card in the 1920s may have been influenced by Meryon's etchings such as *Le Stryge (The Vampire)* (Pl. 105; Fig. 35). In *Night Shadows,* of 1921 (Pl. 82), Hopper's treatment of the silhouetted shadow was used earlier by Meryon in *La Morgue,* yet his startling bird's-eye view from above is closely related to that sometimes employed by the Impressionists as a result of their interest in both photography and Japanese wood-block prints. An even earlier

Fig. 32. John Sloan, *Roofs, Summer Night,* 1906. Etching, 9⅜ × 12⅝ inches. Whitney Museum of American Art, New York; Gift of Gertrude Vanderbilt Whitney 31.826.

Fig. 35. Charles Meryon, *Le Stryge (The Vampire),* 1861. Etching, 6⅛ × 4⁹⁄₁₆ inches. Museum of Art, Carnegie Institute, Pittsburgh; Andrew Carnegie Fund.

Fig. 36. Jean Ignace Isidore Gérard, called Grandville, *Un autre monde: transformations, visions, incarnations,* Paris, 1844. New York Public Library Prints Division.

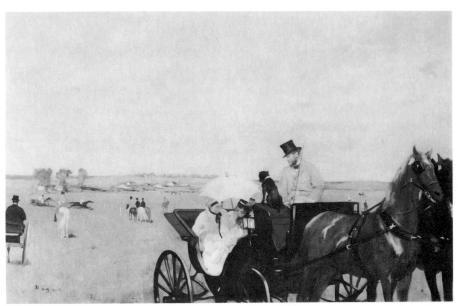

Fig. 37. Edgar Degas, *Carriage at the Races,* 1873. Oil on canvas, 14⅛ × 21⅝ inches. Museum of Fine Arts, Boston.

precedent for this kind of view is one of the wood engravings from Grandville's *Un Autre Monde* (Fig. 36).

Hopper's method of depicting the building in *House on a Hill* of 1920 (Pl. 75) is not unlike that of Meryon, but the treatment of the horse-drawn buggy, partially cut off by the bottom edge of the composition, and its intentional placement (as is indicated by the preliminary drawing) in the extreme lower right corner is close to Degas's *Carriage at the Races* (Fig. 37).

Hopper's involvement with the etching process probably enabled him to deal with compositional issues with a fresh intensity. Before he took up etching, he painted most of his early oils from nature, a process he continued after 1923 only in his watercolors. For several of his etchings, however, he invented his subject matter and composition in the studio, recalling scenes from memory or relying on his imagination. This process of creative improvisation, rather than working directly from his observations, served to refine his ideas into stronger and more consistent designs.

His etching *American Landscape* of 1920 presents straightforwardly a solitary house by railroad tracks which cut emphatically across the composition (Pl. 69). The tracks dramatically divide the composition into horizontal registers, yet the outline of the roof looms up above the trees. This kind of composition is even more powerfully constructed in his oil painting *House By the Railroad* of 1925 where a mansard-roofed Victorian house stands alone against the cutting edge of the rail-

road tracks (Fig. 38). Details such as the trees and cows of the etching have disappeared, allowing all attention to focus on the picturesque forms of the house itself. In the painting he has tilted the previously horizontal line of the tracks inward on a diagonal away from the picture plane into a deeper space. This general compositional format continued to appear in oil paintings such as *Railroad Sunset* of 1929 and *New York, New Haven and Hartford* of 1931 (Figs. 39, 40).

Hopper's etching *The Lighthouse* of 1923 precedes *Lighthouse Hill* of 1927, an oil painting with a closely related composition (Pl. 98; Fig. 41). The painting focuses directly on the hill itself, omitting the sea and the artist sketching from the opposite bank. An even closer view appeared in both his etching *Lighthouse* of 1915–18 and in his oil *Lighthouse at Two Lights* of 1929 (Pl. 18; Fig. 42).

In his etchings Hopper developed and sharpened his ability to portray the lone woman in an urban interior. In some the figure was nude, conveying with intensity a profound sense of intimacy and making the viewer assume the role of voyeur. *Evening Wind* of 1921, the most compelling etching of this theme, is his first fully resolved nude in an interior (Pl. 77). Many oil paintings, variations on this theme, would follow. *Moonlight Interior* of 1921–23 is the closest in both mood and

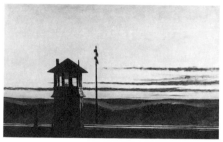

Fig. 39. Edward Hopper, *Railroad Sunset,* 1929. Oil on canvas, 29 × 48 inches. Whitney Museum of American Art, New York; Bequest of Josephine N. Hopper 70.1170.

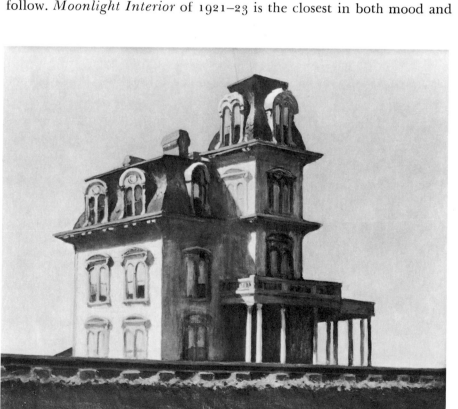

Fig. 38. Edward Hopper, *House By the Railroad,* 1925. Oil on canvas, 24 × 29 inches. The Museum of Modern Art, New York.

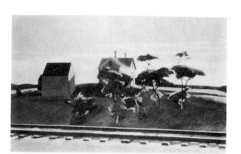

Fig. 40. Edward Hopper, *New York, New Haven and Hartford,* 1931. Oil on canvas, 32 × 50 inches. The John Herron Art Institute, Indianapolis.

composition, but others are also related: *Eleven A.M.* of 1926, *Night Windows* of 1928, *Morning in a City* of 1944, and *A Woman in the Sun* of 1961 (Figs. 43, 44, 45, 46). Other paintings of a woman in an interior relate more closely to *East Side Interior* of 1922 or to *The Bay Window* of 1915–18 (Pls. 85, 10). *Room in Brooklyn*, an oil of 1932, recalls the spatial setting of this latter print, while *Girl at a Sewing Machine* of about 1921 probably preceded the related etching *East Side Interior* (Figs. 47, 48).

Hopper did not easily verbalize the message of either his prints or paintings, but rather preferred to let the viewer formulate a personal impression. When he did commit himself to a specific description of his intentions, it was usually in the form of a denial—what his work was not about. For example, when he wrote in 1956 of his etching *East Side Interior* of 1922 (Pl. 85), he insisted:

> There is little to tell about it. It was entirely improvised from memories of glimpses of rooms seen from the streets in the eastside in my walks in that part of the city. No implication was intended with any ideology concerning the poor and oppressed. The interior itself was my main interest—simply a piece of New York, the city that interests me so much, nor is there any derivation from the so called "Ash Can School" with which my name has at times been erroneously associated.[34]

Although the frequently discussed feelings of loneliness and boredom critics have felt Hopper communicated are the most exaggerated aspect of his work, there is undoubtedly some validity to these responses. It is

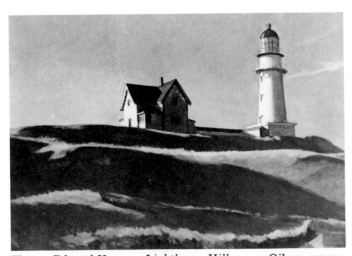

Fig. 41. Edward Hopper, *Lighthouse Hill,* 1927. Oil on canvas, 28¾ × 40⅛ inches. Dallas Museum of Fine Arts.

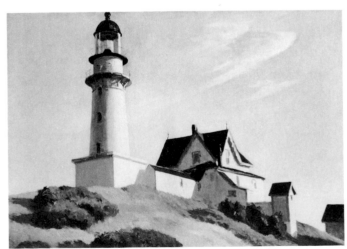

Fig. 42. Edward Hopper, *The Lighthouse at Two Lights,* 1929. Oil on canvas, 29 × 43 inches. The Metropolitan Museum of Art, New York; Hugo Kastor Fund, 1962.

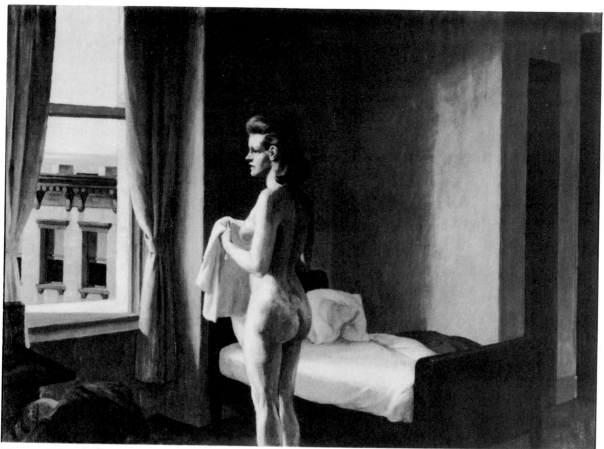

Fig. 45. Edward Hopper, *Morning in a City*, 1944. Oil on canvas, 60 × 44 inches. Williams College Museum of Art, Williamstown, Massachusetts.

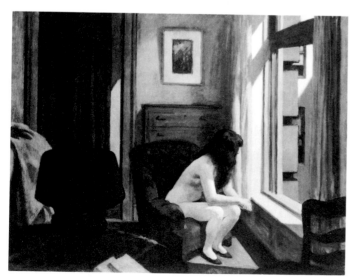

Fig. 43. Edward Hopper, *Eleven A.M.*, 1926. Oil on canvas, 28 × 36 inches. The Hirshhorn Museum and Sculpture Garden, Washington, D.C.

Fig. 44. Edward Hopper, *Night Windows*, 1928. Oil on canvas, 25 × 30 inches. The Museum of Modern Art, New York.

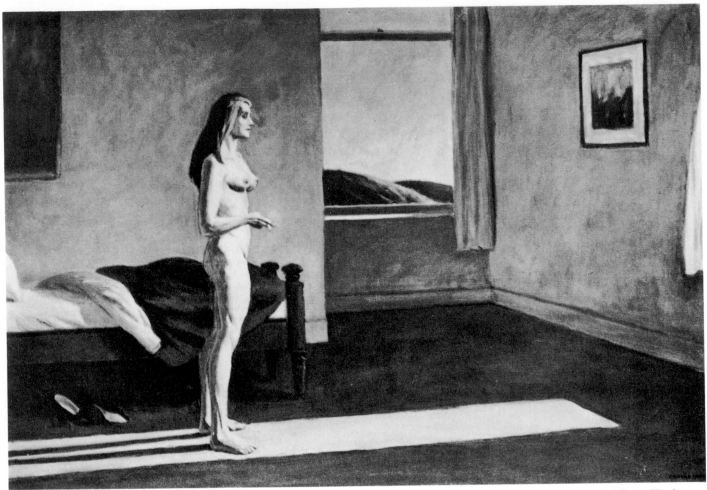

Fig. 46. Edward Hopper, *A Woman in the Sun,* 1961. Oil on canvas, 40 × 60 inches. Collection of Mr. and Mrs. Albert Hackett.

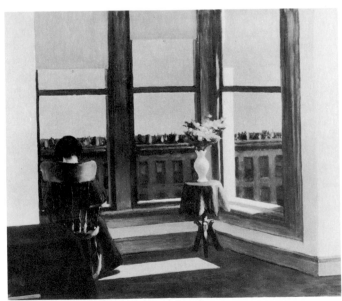

Fig. 47. Edward Hopper, *Room in Brooklyn,* 1932. Oil on canvas, 29 × 34 inches. Museum of Fine Arts, Boston.

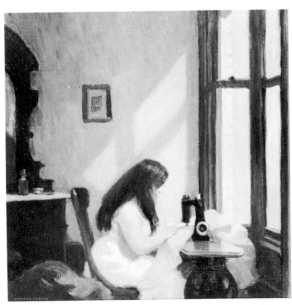

Fig. 48. Edward Hopper, *Girl at a Sewing Machine,* c. 1921. Oil on canvas, 19 × 18 inches. Kennedy Galleries, Inc., New York.

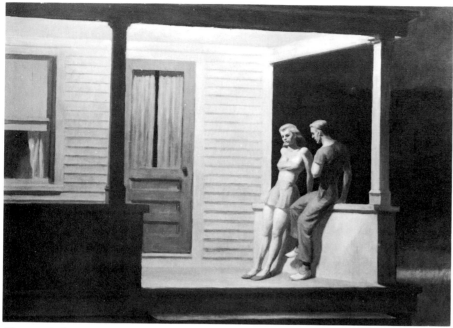

Fig. 49. Edward Hopper, *Summer Evening*, 1947. Oil on canvas, 30 × 40 inches. Private collection.

in his etchings that a sense of loneliness is most authentic. These were all made prior to his marriage to the gregarious Jo Nivison in 1924. Her now-legendary propensity to chatter endlessly as well as her constant presence must have assuaged his loneliness to some extent. Yet his etching *The Lonely House* of 1923 poignantly expresses a profound feeling of isolation. Its very title comments directly on its content, a literary measure he seldom employed. In other etchings he focused on the solitary figure: *The Bay Window, Man by a River, Nude in a Chair,* and *The Open Window,* all of 1915–18; *House by a River,* of 1919; *Night Shadows, Night in the Park,* and *Evening Wind,* all of 1921; *East Side Interior* and *The Railroad,* both of 1922; and *Girl on a Bridge,* of 1923 (Pls. 10, 19, 21, 24, 61, 82, 80, 77, 85, 87, 91).

A few of the etchings which portray couples courting express Hopper's interest in romance. *Summer Afternoon* of 1919–23 is reminiscent of the joyful boating scenes of the Impressionists (Pl. 68). In *Night on the El Train* of 1920, a couple intensely confront one another, engrossed in a serious discussion (Pl. 56). Their twisted postures add to the tenseness of the drama. His fascination with male and female interaction persisted throughout his life and he later pursued it in paintings such as *Summer Evening* of 1947 (Fig. 49).

Other etchings convey the boredom and sense of endless waiting that would later become a leitmotif in paintings such as *New York Movie* of 1939 or *Hotel By a Railroad* of 1952 (Figs. 50, 51). *The Conductor,*

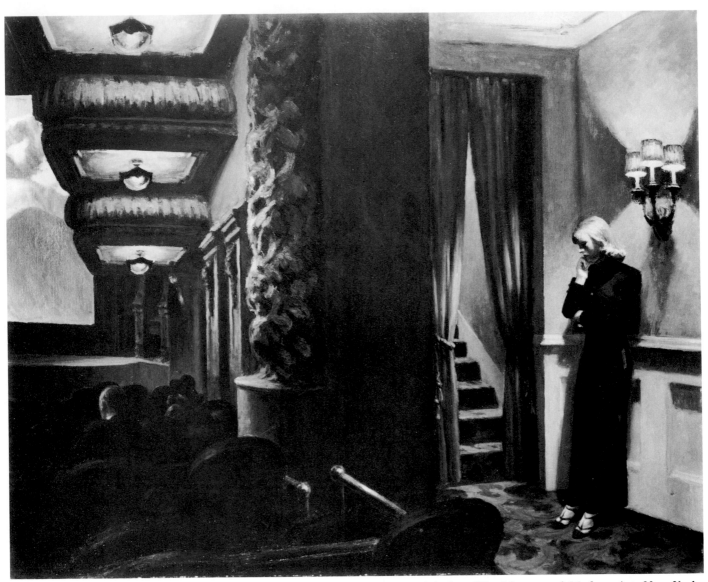

Fig. 50. Edward Hopper, *New York Movie,* 1939. Oil on canvas, 32¼ × 40⅛ inches. The Museum of Modern Art, New York.

an etching of 1919–23, epitomizes this mood of bored disregard (Pl. 62). A similar feeling is presented by the couple in *The El Station* of 1919–23 (Pl. 63).

The levels of meaning of Hopper's etchings depend in part on the projections which various viewers make in confrontation with his imagery. There are often ambiguous situations with several possible interpretations. For example in his *House by a River* the man can be described as lonely and isolated, or relaxed and contemplating the joys of solitude (Pl. 61). Hopper has, however, focused our vision and sharpened our sensibilities through both his compositional design and his ability to render light and shadow. While the levels of meanings in his etchings depend in part on an individual's perceptions, the over-all visual interest consistently remains strong. The majority are straightforward depictions of reality as he observed or recalled it, while occasionally there are flights of the imagination in such works as *Don Quixote* and *The Model,* both of 1915–18, and *Train and Bathers* of 1920 (Pls. 12, 20, 74).

Perhaps more important than serving as a catalyst for his later work, Hopper's etchings stand out for their directness, depth of feeling, and individuality. His prints are intensely expressive works often charged with emotion. He sought to capture the fleeting moment, to find a

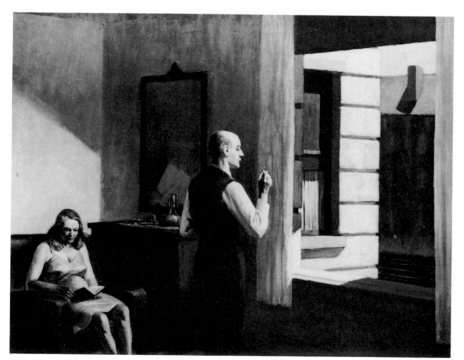

Fig. 51. Edward Hopper, *Hotel by a Railroad,* 1952. Oil on canvas, 31 × 40 inches. The Hirshhorn Museum and Sculpture Garden, Washington, D.C.

personal vision. In this he succeeded, through a simple and straight-forward means. In less than a decade he mastered a medium previously unfamiliar to him and produced nearly seventy prints, several of them masterpieces. He finished his last etching in 1923, spending that summer in Gloucester, Massachusetts, where he began to paint watercolors regularly. Although he produced his last two drypoints in 1928, he recognized the importance of his prints in the context of his work and was proud to have his best ones included in all of his retrospective exhibitions. As his friend and former classmate Guy Pène du Bois wrote, "Hopper does not belong to the rank and file of etchers," but "is an artist." [35] Rembrandt and Goya were two artists Hopper especially admired; they, like him, were primarily painters and yet produced highly expressive etchings. Like them, Hopper is outstanding among his contemporaries for his very original vision in both his prints and his paintings.

PLATES

Brackets indicate titles given by the author to works not previously listed by Zigrosser or by Hopper in ledgers or on the print.

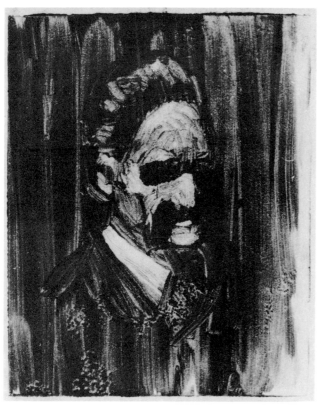

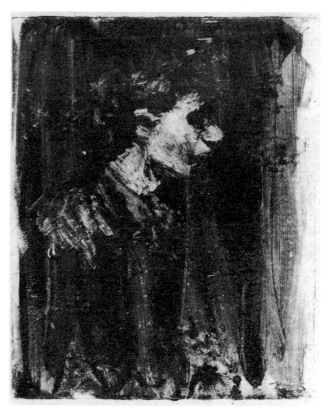

Pl. 1. [*Man's Head*], c. 1902. Monotype, 4¼ × 3¼ inches. Whitney Museum of American Art, New York; Bequest of Josephine N. Hopper 70.1560.100.

Pl. 2. [*Boy's Head*], c. 1902. Monotype, 4¼ × 3¼ inches. Whitney Museum of American Art, New York; Bequest of Josephine N. Hopper 70.1560.99.

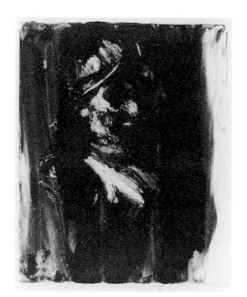

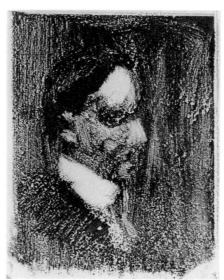

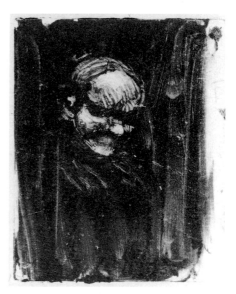

Pl. 3. [*Portrait Head*], c. 1902. Monotype on envelope from the New York School of Art, postmarked 12 November 1902; 4¼ × 3¼ inches. Private collection.

Pl. 4. [*Portrait Head*], c. 1902. Monotype on envelope postmarked 30 September 1902; 4¾ × 3½ inches. Private collection.

Pl. 5. [*Portrait Head*], c. 1902. Monotype, 4¼ × 3¼ inches. Private collection.

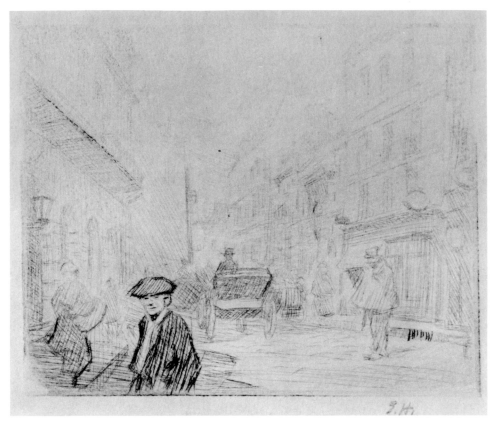

Pl. 6. [*Paris Street Scene with Carriage*], 1915–18. Etching, 4 × 5 inches. Whitney Museum of American Art, New York; Bequest of Josephine N. Hopper 70.1072.

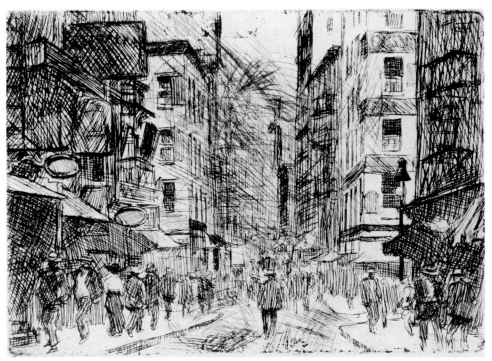

Pl. 7. [*City Street Scene*], c. 1915. Etching with drypoint; plate, 4⅞ × 6¾ inches. Exists only in posthumous print. Whitney Museum of American Art, New York; plate, Bequest of Josephine N. Hopper.

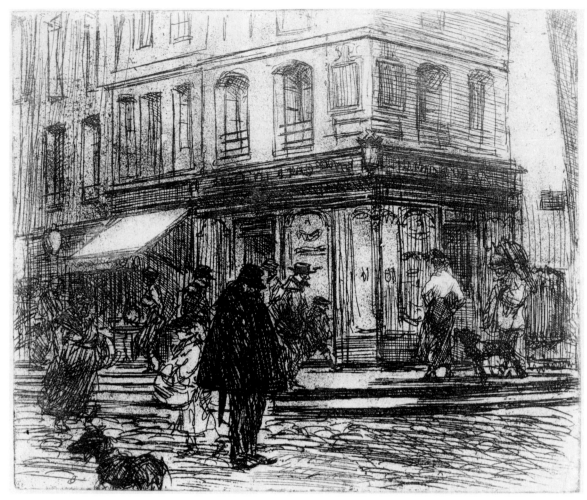

Pl. 8. *Street in Paris,* 1915–18. Etching, 7⅞ × 9½ inches. Whitney Museum of American Art, New York; Bequest of Josephine N. Hopper 70.1071.

Pl. 9. *St. Nicholas Terrace,* 1915–18. Etching, 2¹¹⁄₁₆ × 3⅝ inches. Whitney Museum of American Art, New York; Bequest of Josephine N. Hopper 70.1077.

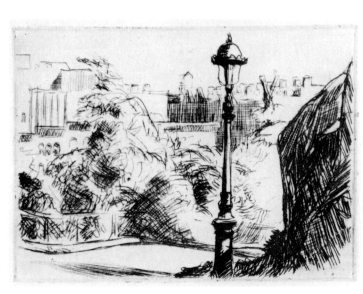

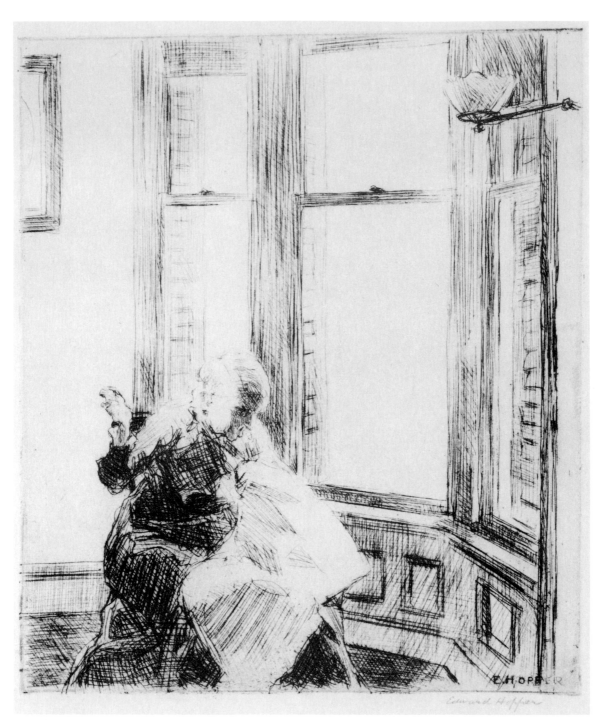

Pl. 10. *The Bay Window*, 1915–18. Etching, 7 × 6 inches. Whitney Museum of American Art, New York; Bequest of Josephine N. Hopper 70.1060.

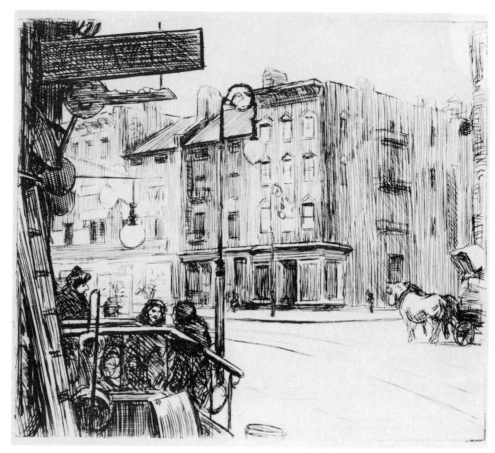

Pl. 11. *Carmine Street,* 1915–18. Etching, 7 × 8 inches. Whitney Museum of American Art, New York; Bequest of Josephine N. Hopper 70.1061.

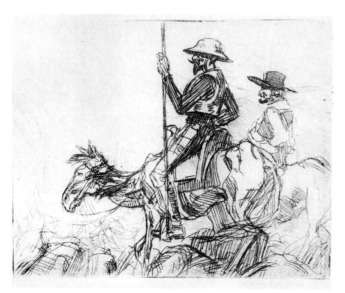

Pl. 12. *Don Quixote,* 1915–18. Etching, 4 × 5 inches. Whitney Museum of American Art, New York; Bequest of Josephine N. Hopper 70.1063.

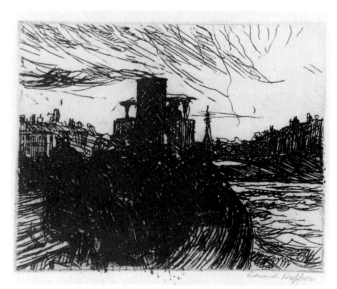

Pl. 13. *Evening, the Seine,* 1915–18. Etching, 4 × 5 inches. Whitney Museum of American Art, New York; Bequest of Josephine N. Hopper 70.1064.

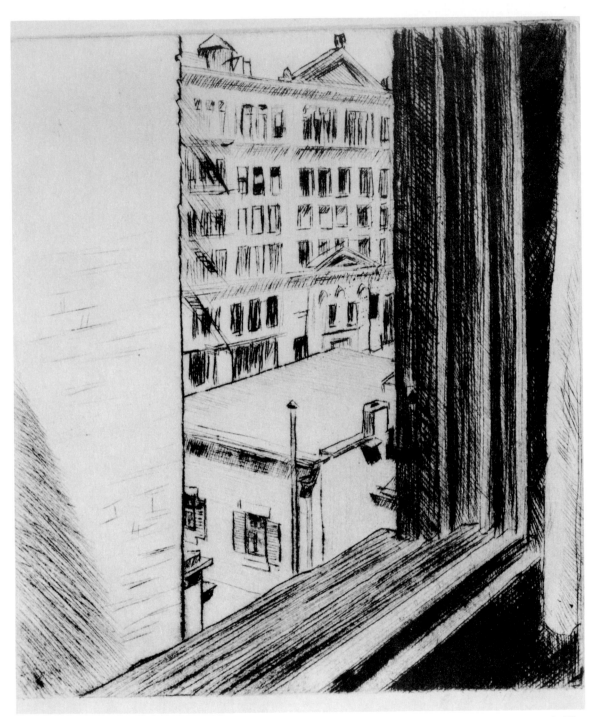

Pl. 14. *From My Window,* 1915–18. Drypoint, 7 × 6 inches. Philadelphia Museum of Art: Purchased: The Harrison Fund.

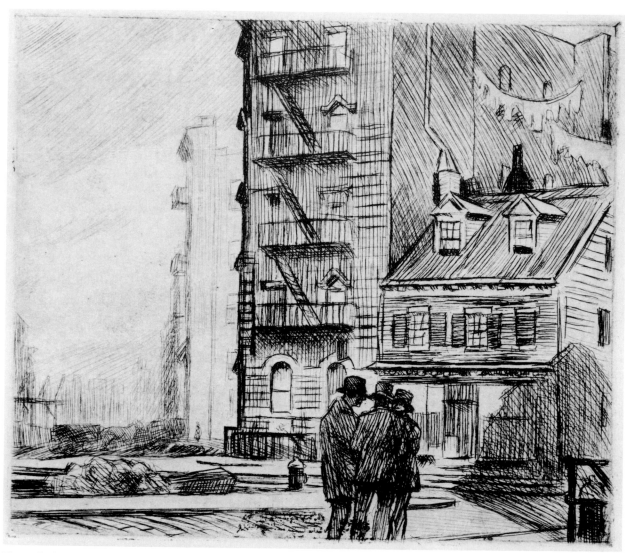

Pl. 15. [*City Scene with Tenements*], 1915–18. Etching; plate, 6 × 7 inches. Exists only in posthumous print. Whitney Museum of American Art, New York; plate, Bequest of Josephine N. Hopper.

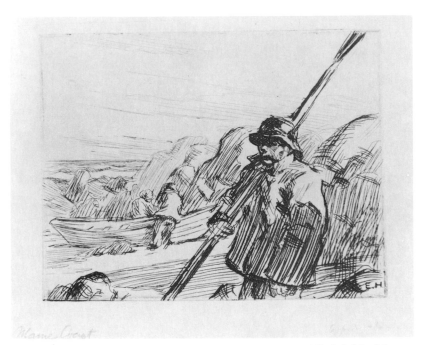

Pl. 16. *Maine Coast,* 1915–18. Etching, 4 × 5 inches. Philadelphia Museum of Art: Purchased: The Harrison Fund.

Pl. 17. [*Tree and Fence*], 1915–18. Etching; plate, 4 × 5 inches. Exists only in post-humous print. Whitney Museum of American Art, New York; plate, Bequest of Josephine N. Hopper. Verso has a heavily canceled image of a seated woman and a reclining man.

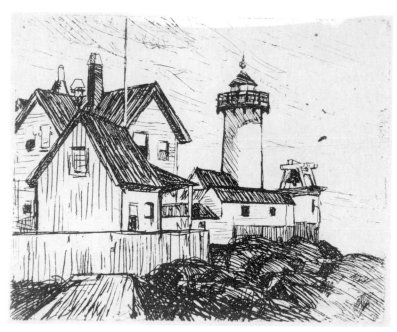

Pl. 18. [*Lighthouse*], 1915–18. Etching; plate, 4 × 5 inches. Exists only in posthumous print. Whitney Museum of American Art, New York; plate, Bequest of Josephine N. Hopper.

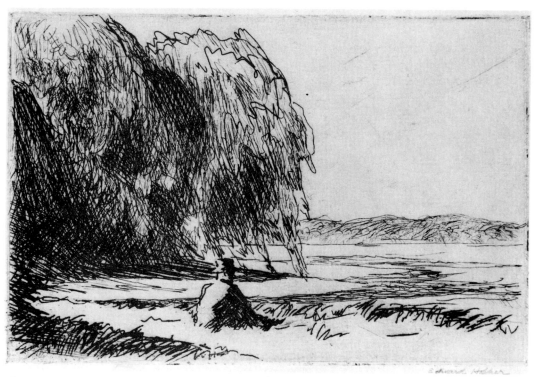

Pl. 19. *Man by a River*, 1915–18. Etching, 4 × 6 inches. Philadelphia Museum of Art: Purchased: The Harrison Fund.

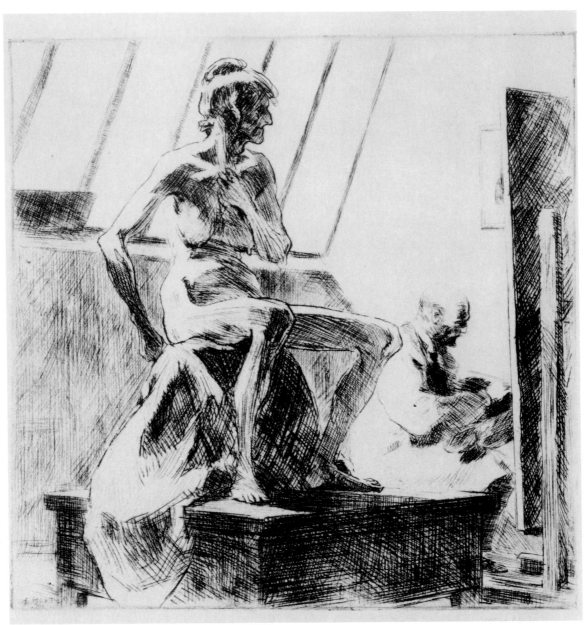

Pl. 20. *The Model*, 1915–18. Etching, 7 × 7 inches. Whitney Museum of American Art, New York; Bequest of Josephine N. Hopper 70.1065.

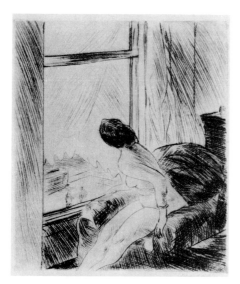

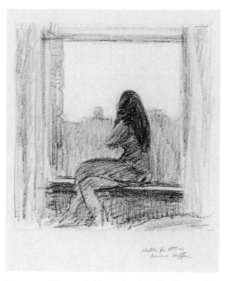

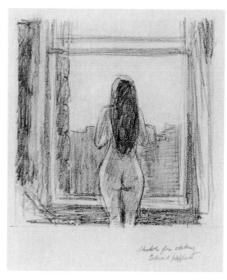

Pl. 21. *Nude in a Chair,* 1915–18. Drypoint, 6 × 5 inches. Philadelphia Museum of Art: Purchased: The Harrison Fund.

Pl. 22. [*Seated Female Nude by Window*], 1915–18. Conte on paper, 14⅞ × 10 inches. Whitney Museum of American Art, New York; Bequest of Josephine N. Hopper 70.830.

Pl. 23. [*Standing Female Nude by Window*], 1915–18. Conte on paper, 15 × 10 inches. Whitney Museum of American Art, New York; Bequest of Josephine N. Hopper 70.831.

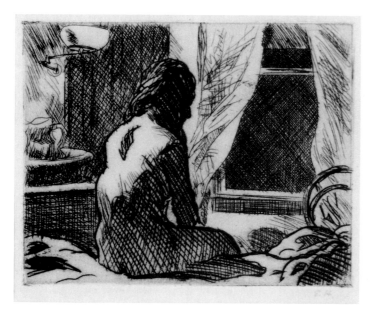

Pl. 24. *The Open Window,* 1915–18. Etching, 4 × 5 inches. Kennedy Galleries, Inc., New York.

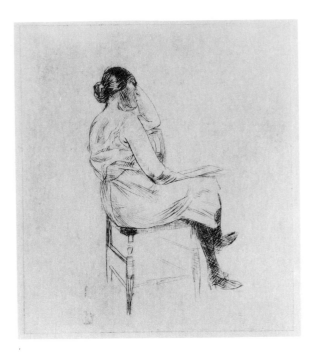

Pl. 25. [*Woman in Chair*], 1915–18. Etching; plate, 8 × 7 inches. Exists only in posthumous print. Whitney Museum of American Art, New York; plate, Bequest of Josephine N. Hopper.

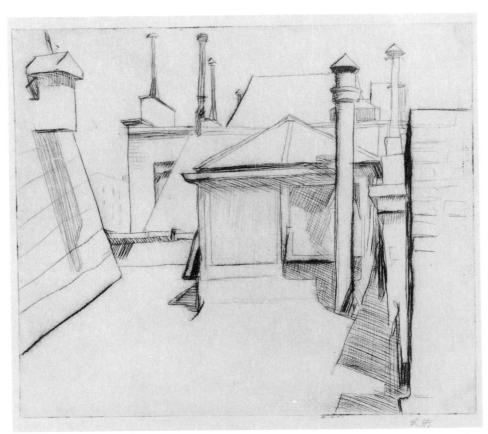

Pl. 26. *On My Roof*, 1915–18. Drypoint, 5 × 6 inches. Whitney Museum of American Art, New York; Bequest of Josephine N. Hopper 70.1066.

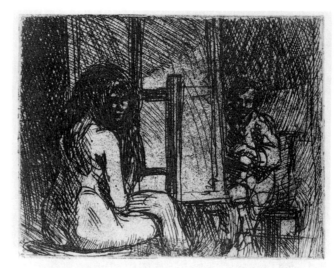

Pl. 27. *The Painter,* 1915–18. Etching, 4 × 5 inches. Philadelphia Museum of Art: Purchased: The Harrison Fund.

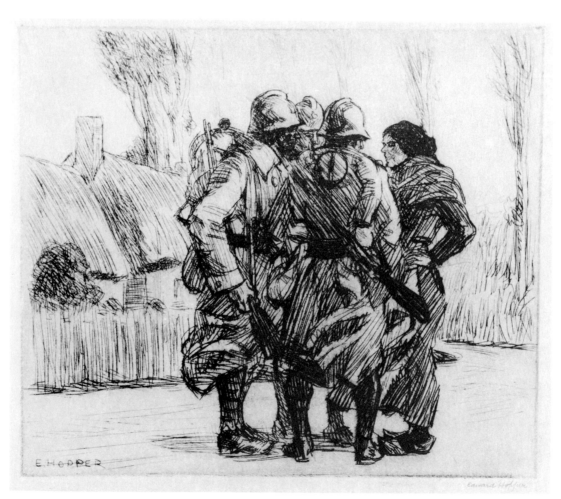

Pl. 28. *Les Poilus,* 1915–18. Etching 6 × 7 inches. Whitney Museum of American Art, New York; Bequest of Josephine N. Hopper 70.1069.

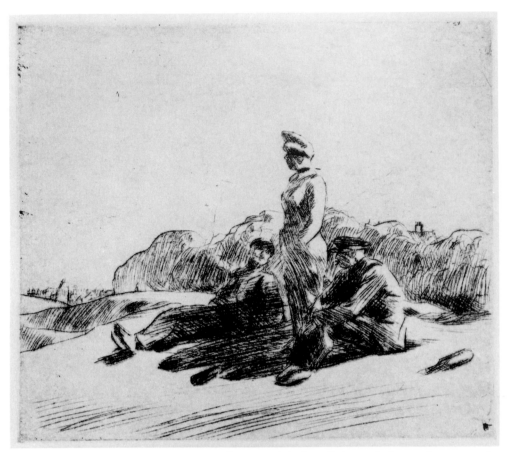

Pl. 29. *La Barrière*, 1915–18. Drypoint; plate, 7 × 8 inches. Exists only in posthumous print. Whitney Museum of American Art, New York; plate, Bequest of Josephine N. Hopper.

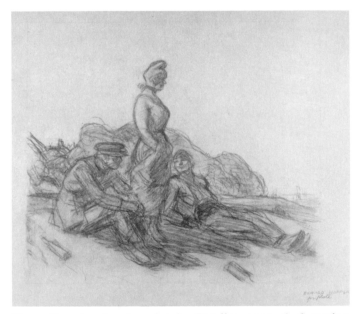

Pl. 30. Drawing for drypoint *La Barrière*, 1915–18. Sanguine on paper, 16 × 19 inches. Whitney Museum of American Art, New York; Bequest of Josephine N. Hopper 70.886.

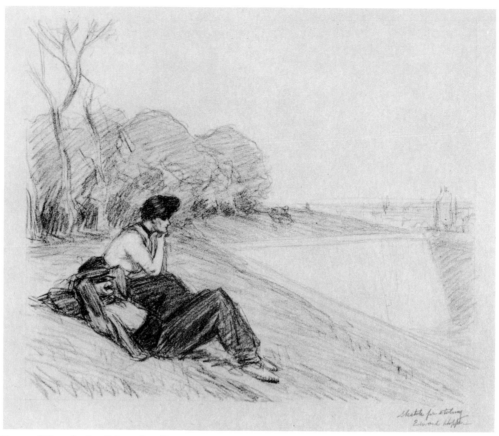

Pl. 31. [*Couple by River Bank*], 1915–18. Conte on paper, 12¾ × 14¹⁵⁄₁₆ inches. Whitney Museum of American Art, New York; Bequest of Josephine N. Hopper 70.875.

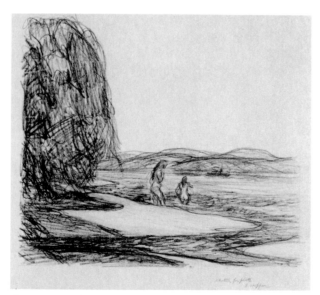

Pl. 32. [*Female Bathers*], 1915–18. Conte on paper, 16 × 18¹¹⁄₁₆ inches. Whitney Museum of American Art, New York; Bequest of Josephine N. Hopper 70.896.

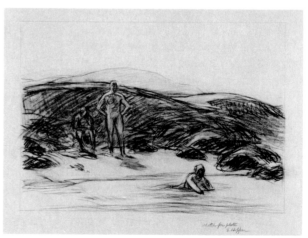

Pl. 33. [*Three Male Bathers*], 1915–18. Conte on paper, 14⁵⁄₁₆ × 18⁵⁄₁₆ inches. Whitney Museum of American Art, New York; Bequest of Josephine N. Hopper 70.895.

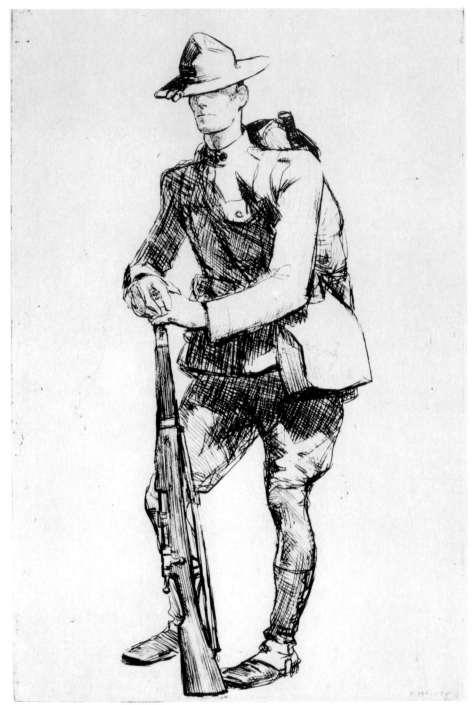

Pl. 34. *The Yank*, 1915–18. Etching; plate, 10 × 6½ inches. Exists only in posthumous print. Whitney Museum of American Art, New York; plate, Bequest of Josephine N. Hopper.

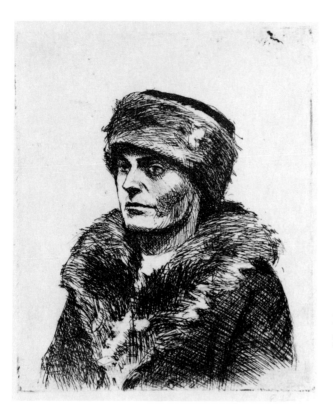

Pl. 35. *Portrait of Jeanne Cheruy,* 1915–18. Etching, 4 × 3¼ inches. Philadelphia Museum of Art: Purchased: The Harrison Fund.

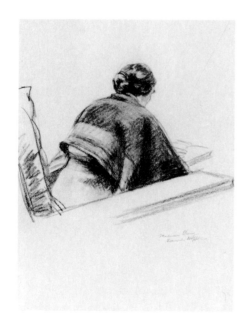

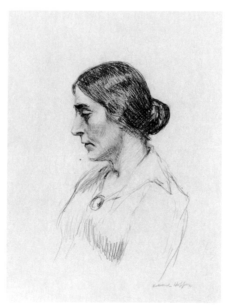

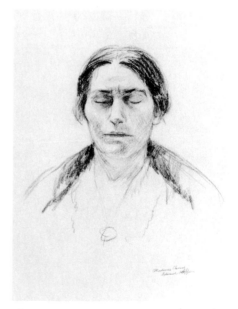

Pl. 36. Drawing related to etching *Portrait of Jeanne Cheruy,* 1915–18. Conte on paper, 16½ × 10¾ inches. Whitney Museum of American Art, New York; Bequest of Josephine N. Hopper 70.873.

Pl. 37. Drawing related to etching *Portrait of Jeanne Cheruy,* 1915–18. Pencil on paper, 14 × 19¹⁄₁₆ inches. Whitney Museum of American Art, New York; Bequest of Josephine N. Hopper 70.871.

Pl. 38. Drawing related to etching *Portrait of Jeanne Cheruy,* 1915–18. Conte on paper, 16½ × 10½ inches. Whitney Museum of American Art, New York; Bequest of Josephine N. Hopper 70.872.

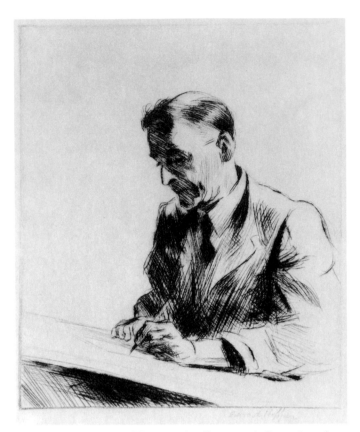

Pl. 39. *Portrait of William V. Graff*, 1915–18. Drypoint, 6 × 5 inches. Philadelphia Museum of Art: Purchased: The Harrison Fund.

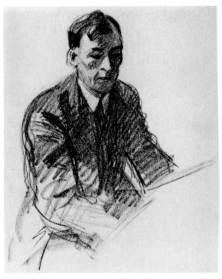

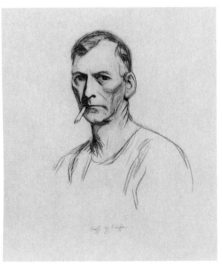

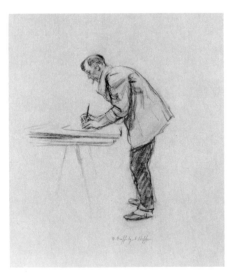

Pl. 40. Drawing related to etching *Portrait of William V. Graff*, 1915–18. Conte on paper, 20¹⁄₁₆ × 13½ inches. Whitney Museum of American Art, New York; Bequest of Josephine N. Hopper 70.980.

Pl. 41. Drawing related to etching *Portrait of William V. Graff*, 1915–18. Sanguine on paper, 21 × 16 inches. Whitney Museum of American Art, New York; Bequest of Josephine N. Hopper 70.879.

Pl. 42. Drawing related to etching *Portrait of William V. Graff*, 1915–18. Sanguine on paper, 15½ × 14 inches. Whitney Museum of American Art, New York; Bequest of Josephine N. Hopper 70.880.

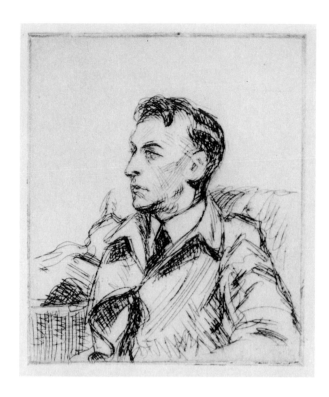

Pl. 43. [*Portrait of William V. Graff*], 1915–18. Etching, 4 × 3¼ inches. Whitney Museum of American Art, New York; Bequest of Josephine N. Hopper 70.1075.

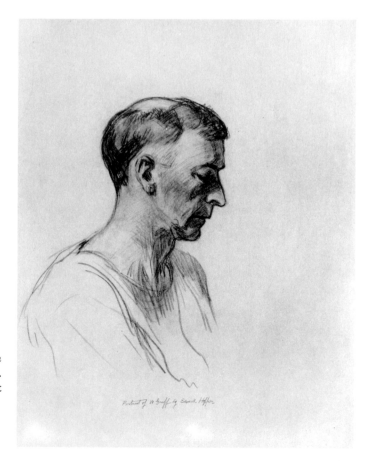

Pl. 44. Drawing related to etching [*Portrait of William V. Graff*], 1915–18. Sanguine on paper, 21 × 16 inches. Whitney Museum of American Art, New York; Bequest of Josephine N. Hopper 70.876.

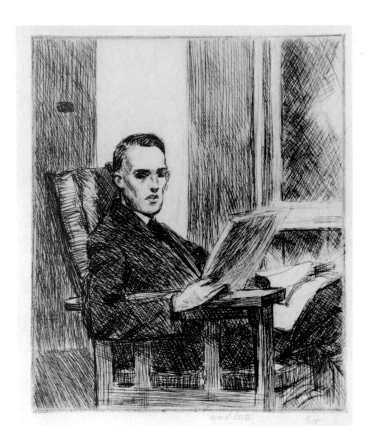

Pl. 45. [*Portrait of Arthur Cederquist*], 1915–18. Etching, 6 × 5 inches. Whitney Museum of American Art, New York; Bequest of Josephine N. Hopper 70.1073.

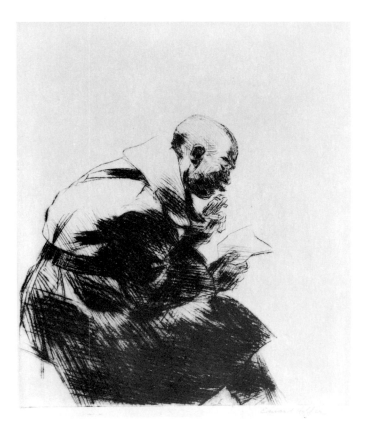

Pl. 46. *Soldier Reading*, 1915–18. Drypoint, 6 × 5 inches. Philadelphia Museum of Art: Purchased: The Harrison Fund.

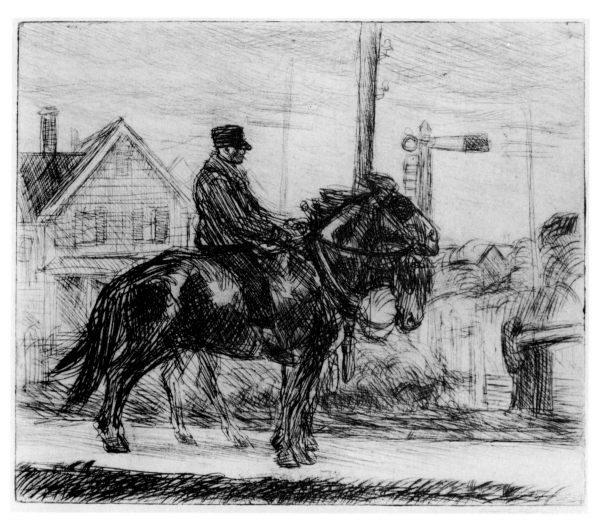

Pl. 47. *Team of Horses,* 1915–18. Drypoint, 6 × 7 inches. Philadelphia Museum of Art: Purchased: The Harrison Fund.

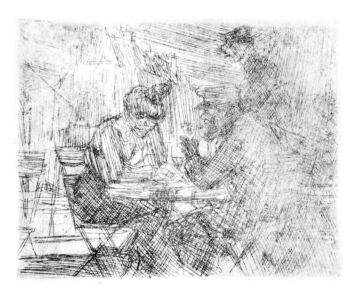

Pl. 48. [*Cafe*], 1915–18. Etching; plate, 4 × 5 inches. Exists only in posthumous print. Whitney Museum of American Art, New York; plate, Bequest of Josephine N. Hopper.

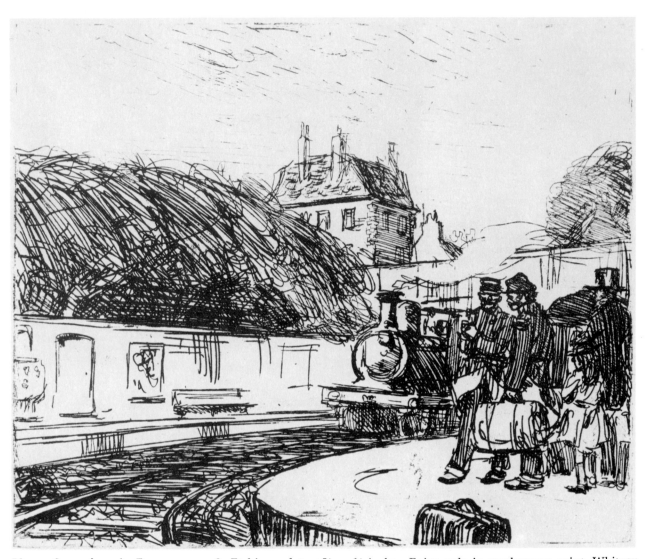

Pl. 49. *Somewhere in France,* 1915–18. Etching; plate, 7⅞ × 9½ inches. Exists only in posthumous print. Whitney Museum of American Art, New York; plate, Bequest of Josephine N. Hopper.

Pl. 50. *The Bull Fight,* c. 1917. Etching, 4⅞ × 7 inches. Whitney Museum of American Art, New York; Bequest of Josephine N. Hopper 70.1006.

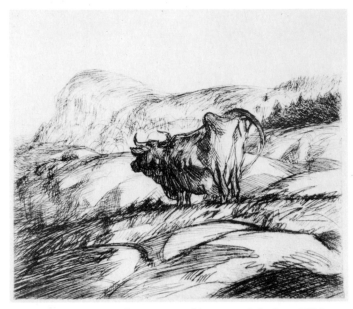

Pl. 51. *Cow and Rocks,* 1918. Etching, 7 × 8 inches. Whitney Museum of American Art, New York; Bequest of Josephine N. Hopper 70.1014.

Pl. 52. *The Monhegan Boat,* 1918. Etching, 7 × 9 inches. Whitney Museum of American Art, New York; Bequest of Josephine N. Hopper 70.1044.

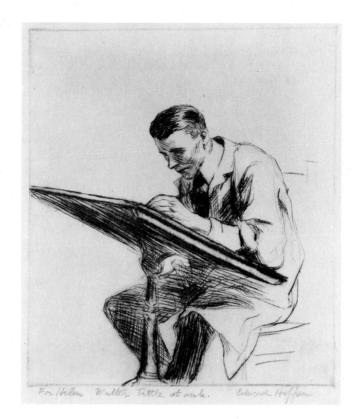

Pl. 53. *Walter Tittle Drawing*, 1918. Drypoint, 6 × 5 inches. Philadelphia Museum of Art: Purchased: The Harrison Fund.

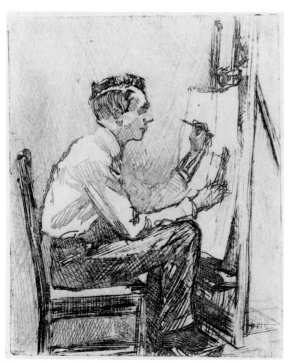

Pl. 54. *Portrait of Walter Tittle* or [*The Illustrator*], 1918. Etching, 5 × 4 inches. Whitney Museum of American Art, New York; Bequest of Josephine N. Hopper 70.1079.

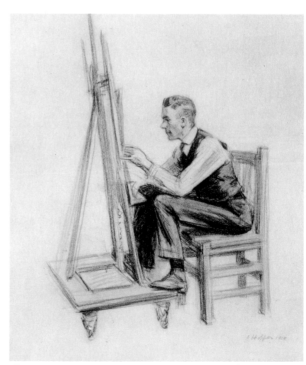

Pl. 55. Drawing related to etching *Portrait of Walter Tittle* or [*The Illustrator*], 1918. Conte on illustration board, 12¾ × 11¹¹/₁₆ inches. Wittenberg University Library, Springfield, Ohio.

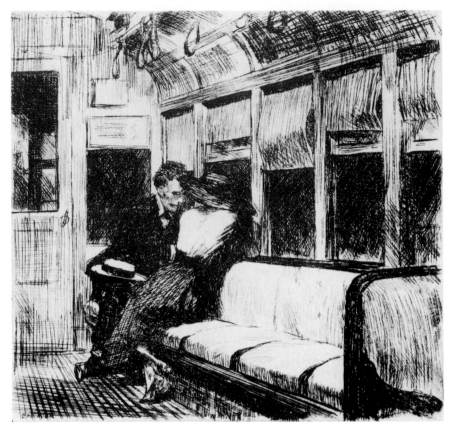

Pl. 56. *Night on the El Train*, 1918. Etching, 7½ × 8 inches. Philadelphia Museum of Art: Purchased: The Harrison Fund.

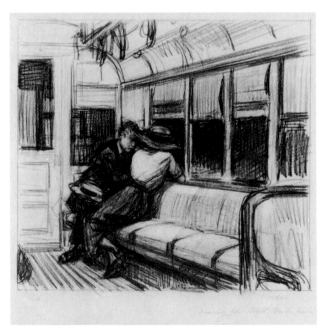

Pl. 57. Drawing for etching *Night on the El Train*, 1918. Charcoal on paper, 7¼ × 8 inches. Collection of Mr. and Mrs. Peter R. Blum.

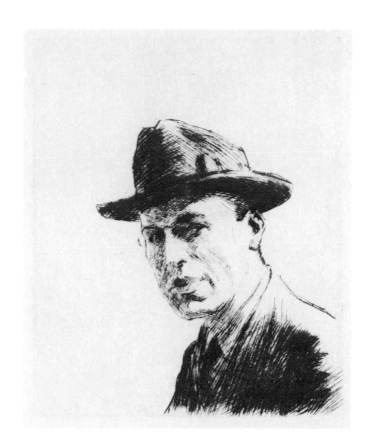

Pl. 58. [*Self-Portrait with Hat*], c. 1918. Drypoint;
plate, 5 × 4 inches. Exists only in posthumous print.
Whitney Museum of American Art, New York;
plate, Bequest of Josephine N. Hopper.

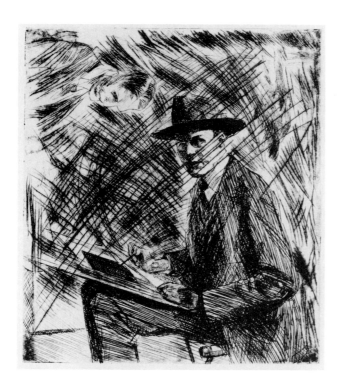

Pl. 59. [*Seated Self-Portrait with nude and portrait*],
c. 1918. Etching with drypoint; plate, 8 × 7 inches.
Exists only in posthumous print. Whitney Museum
of American Art, New York; plate, Bequest of
Josephine N. Hopper.

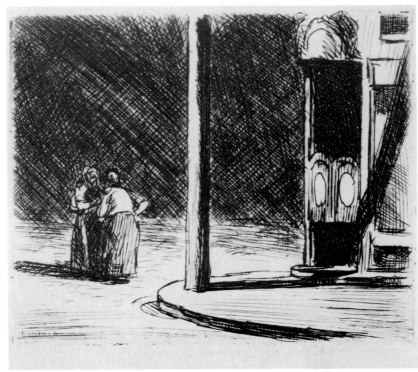

Pl. 60. *A Corner,* 1919. Etching, 3¼ × 4 inches. Whitney Museum of American Art, New York; Bequest of Josephine N. Hopper 70.1011.

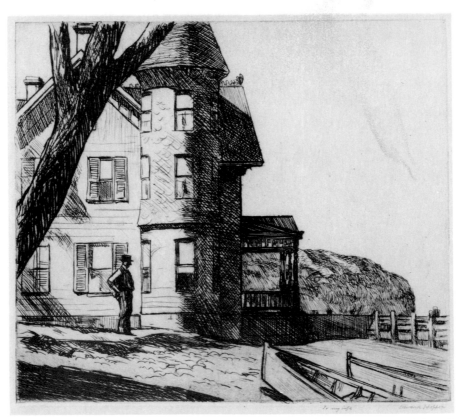

Pl. 61. *House by a River,* 1919. Etching, 7 × 8 inches. Whitney Museum of American Art, New York; Bequest of Josephine N. Hopper 70.1030.

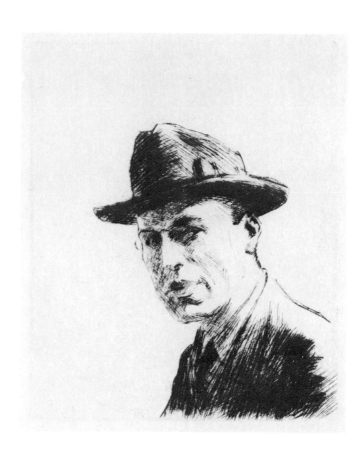

Pl. 58. [*Self-Portrait with Hat*], c. 1918. Drypoint; plate, 5 × 4 inches. Exists only in posthumous print. Whitney Museum of American Art, New York; plate, Bequest of Josephine N. Hopper.

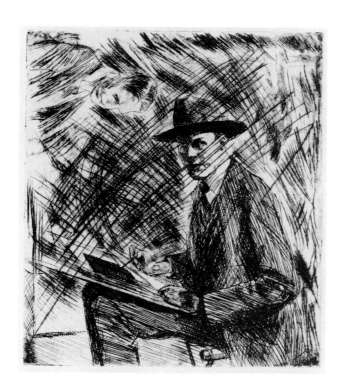

Pl. 59. [*Seated Self-Portrait with nude and portrait*], c. 1918. Etching with drypoint; plate, 8 × 7 inches. Exists only in posthumous print. Whitney Museum of American Art, New York; plate, Bequest of Josephine N. Hopper.

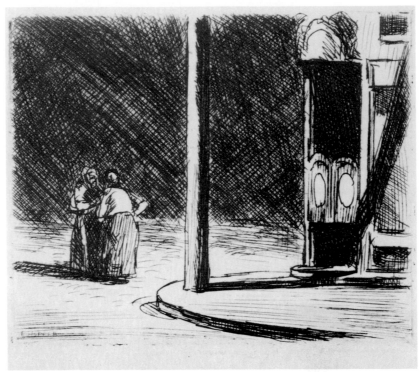

Pl. 60. *A Corner,* 1919. Etching, 3¼ × 4 inches. Whitney Museum of American Art, New York; Bequest of Josephine N. Hopper 70.1011.

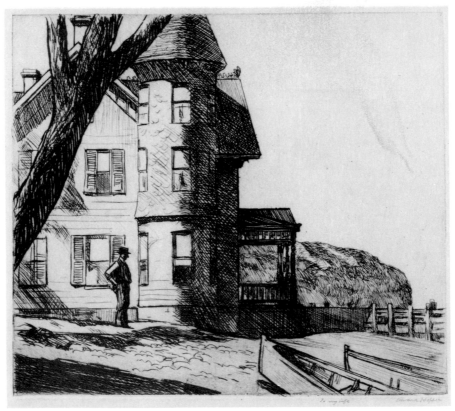

Pl. 61. *House by a River,* 1919. Etching, 7 × 8 inches. Whitney Museum of American Art, New York; Bequest of Josephine N. Hopper 70.1030.

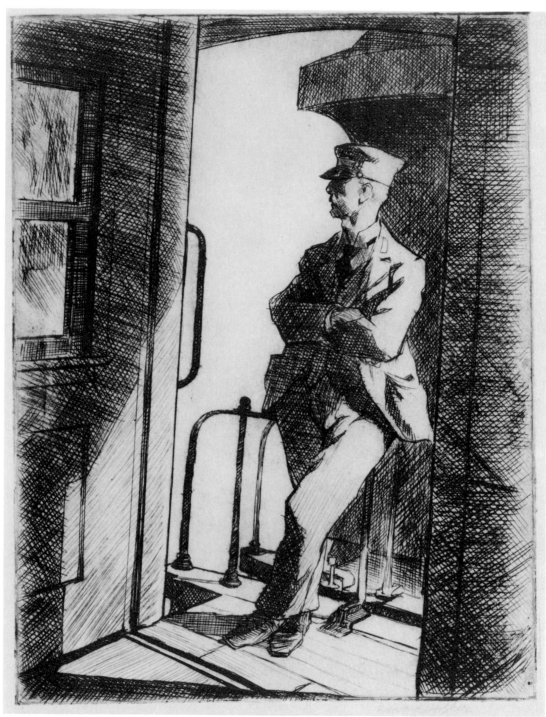

Pl. 62. *The Conductor*, 1919–23. Etching, 8 × 6 inches. Philadelphia Museum of Art: Purchased: The Harrison Fund.

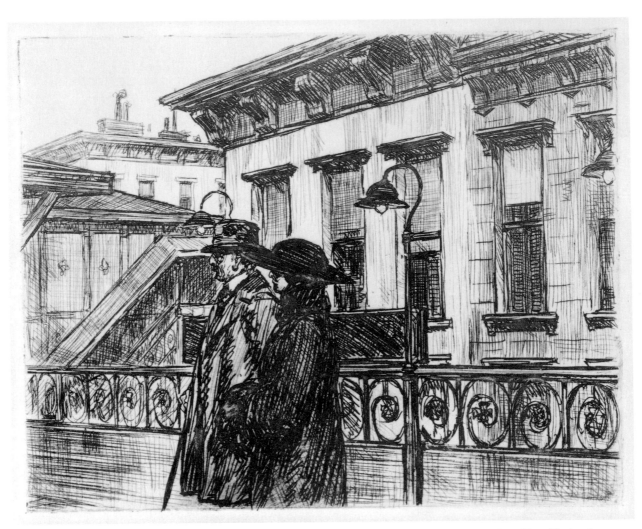

Pl. 63. *The El Station*, 1919–23. Etching, 7 × 9 inches. Whitney Museum of American Art, New York; Bequest of Josephine N. Hopper 70.1056.

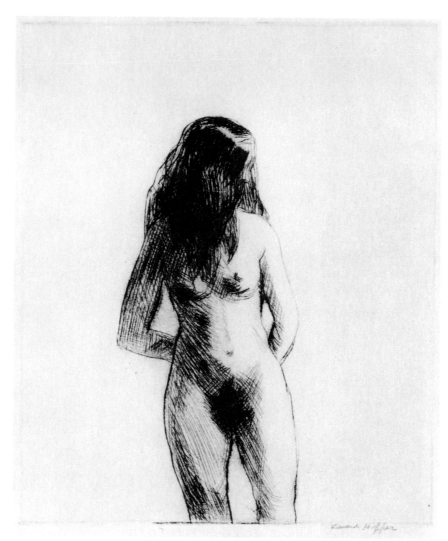

Pl. 64. *Nude Facing Front,* 1919–23. Drypoint, 6 × 5 inches. Philadelphia Museum of Art: Purchased: The Harrison Fund.

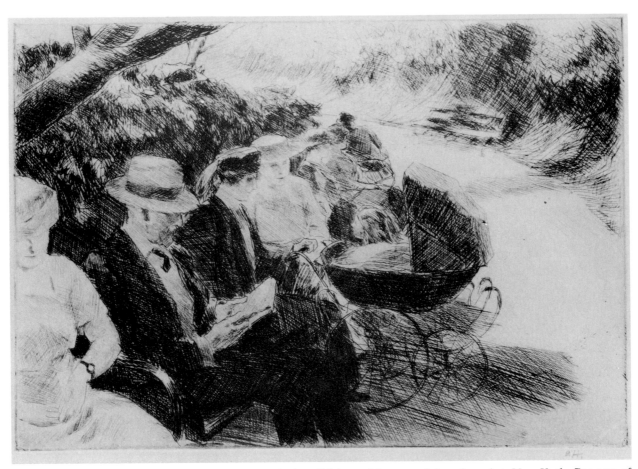

Pl. 65. *People in a Park,* 1919–23. Etching, 7 × 10 inches. Whitney Museum of American Art, New York; Bequest of Josephine N. Hopper 70.1057.

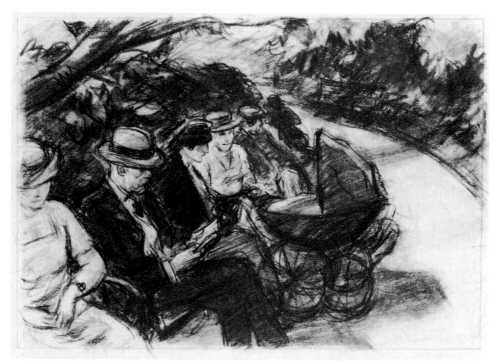

Pl. 66. Drawing for etching *People in a Park*, 1919–23. Pencil on paper, 7½ × 10½ inches. Private collection; courtesy Kennedy Galleries, Inc., New York.

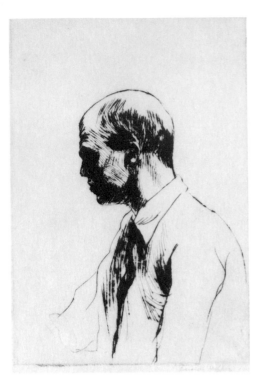

Pl. 67. *Self-Portrait,* 1919–23. Drypoint, 6 × 4 inches. Philadelphia Museum of Art: Purchased: The Harrison Fund.

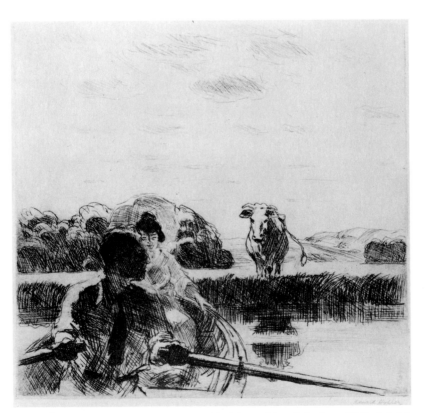

Pl. 68. *Summer Afternoon,* 1919–23. Etching, 7½ × 8 inches. Philadelphia Museum of Art: Purchased: The Harrison Fund.

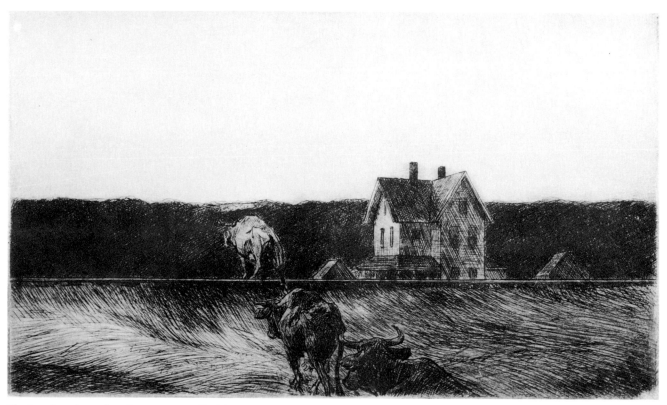

Pl. 69. *American Landscape,* 1920. Etching, 7½ × 12½ inches. Whitney Museum of American Art, New York; Gift of Gertrude Vanderbilt Whitney 31.609.

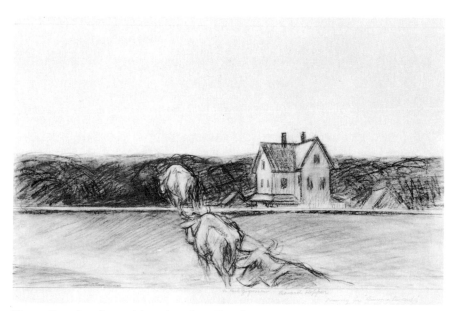

Pl. 70. Drawing for etching *American Landscape,* 1920. Charcoal on paper, 10 × 14 inches. Philadelphia Museum of Art: Purchased: The Harrison Fund.

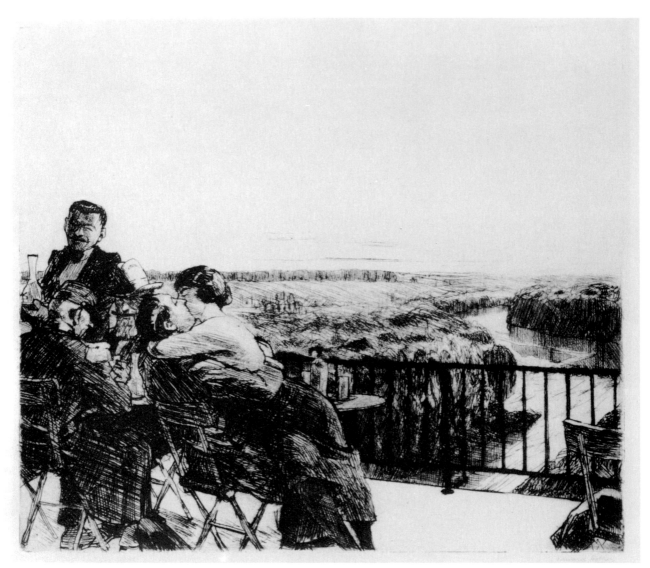

Pl. 71. *Les Deux Pigeons,* 1920. Etching, 8½ × 10 inches. Philadelphia Museum of Art: Purchased: The Harrison Fund.

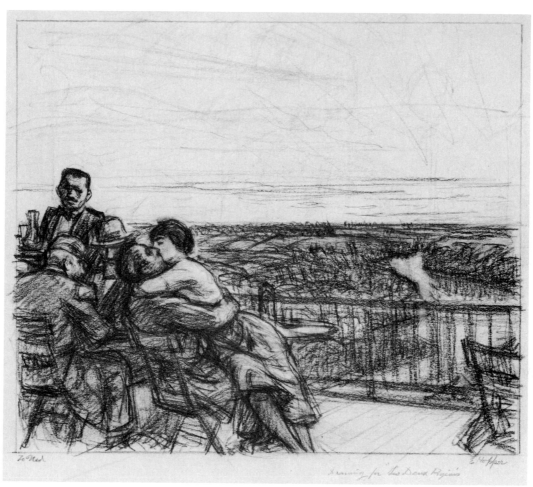

Pl. 72. Drawing for etching *Les Deux Pigeons*, 1920. Charcoal on paper, 8½ × 10 inches. Collection of Mr. and Mrs. Peter R. Blum.

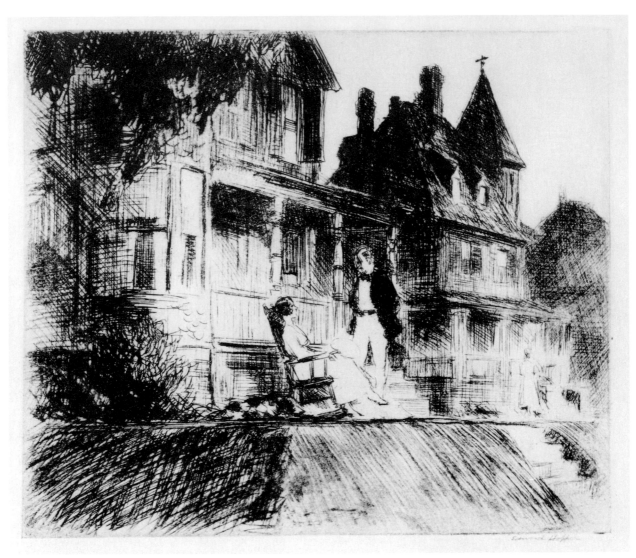

Pl. 73. *Summer Twilight,* 1920. Etching, 8½ × 10 inches. Whitney Museum of American Art, New York; Bequest of Josephine N. Hopper 70.1055.

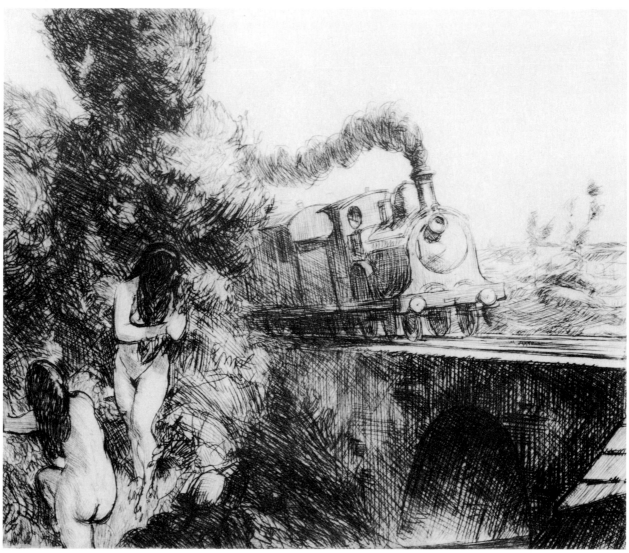

Pl. 74. *Train and Bathers,* 1920. Etching, 8½ × 10 inches. Whitney Museum of American Art, New York; Bequest of
Josephine N. Hopper 70.1055.

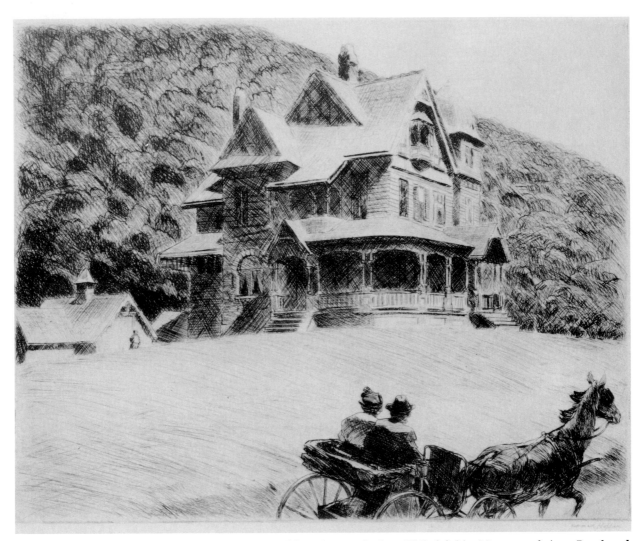

Pl. 75. *House on a Hill* or *The Buggy*, 1920. Etching, 8 × 10 inches. Philadelphia Museum of Art: Purchased: The Harrison Fund.

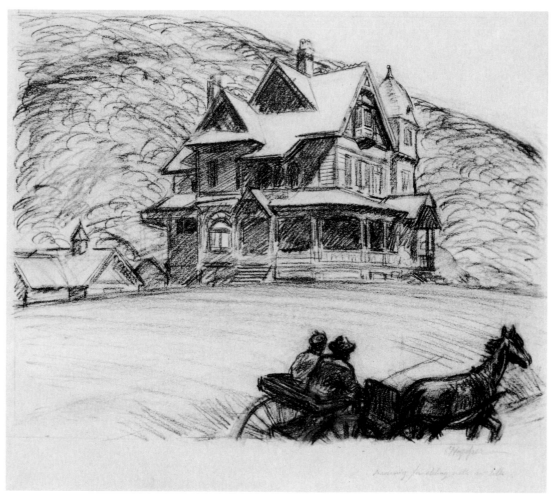

Pl. 76. Drawing for etching *House on a Hill*, 1920. Conte on paper, 8½ × 10¾ inches. Private collection; courtesy Kennedy Galleries, Inc., New York.

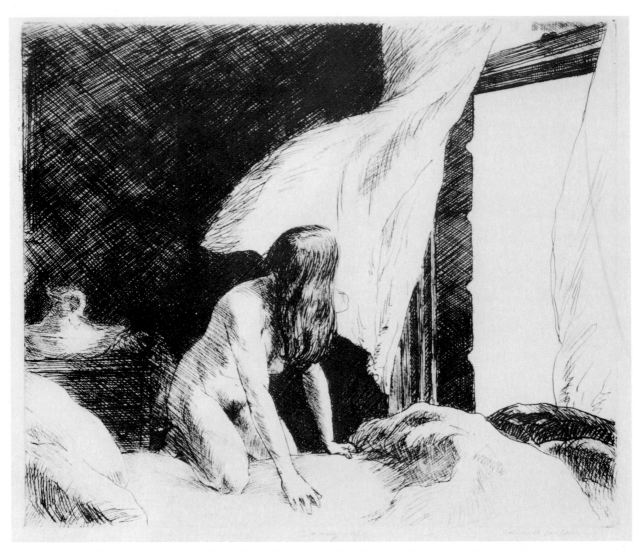

Pl. 77. *Evening Wind* (occasionally called *Night Wind*), 1921. Etching, 7 × 8⅜ inches. Whitney Museum of American Art, New York; Bequest of Josephine N. Hopper 70.1022.

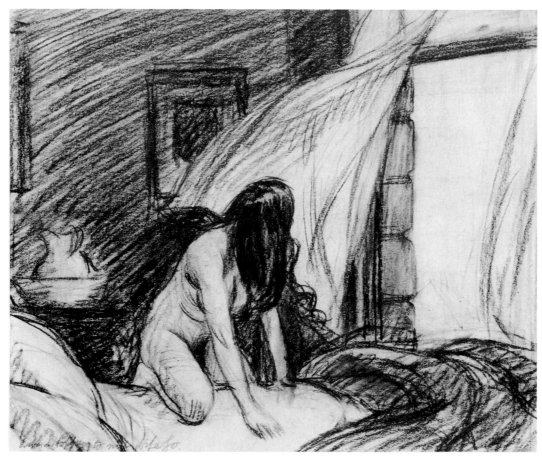

Pl. 78. Drawing for etching *Evening Wind*, 1921. Conte and charcoal on paper, 10 × 13¹⁵⁄₁₆ inches.
Whitney Museum of American Art, New York; Bequest of Josephine N. Hopper 70.343.

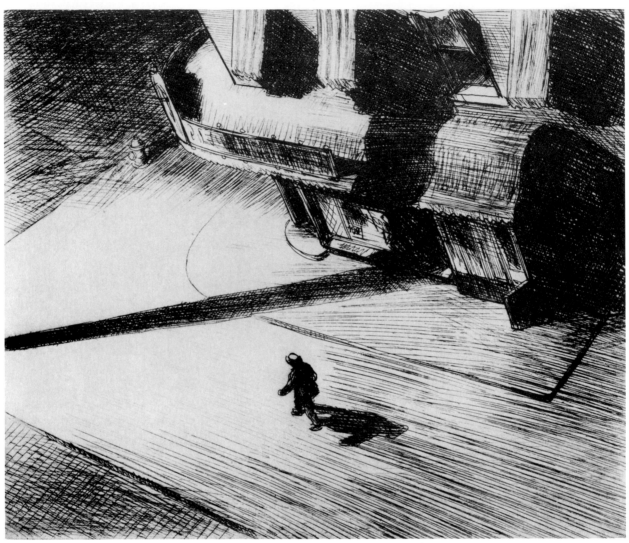

Pl. 82. *Night Shadows,* 1921. Etching, 7 × 8⅜ inches. Whitney Museum of American Art, New York; Bequest of Josephine N. Hopper 70.1048.

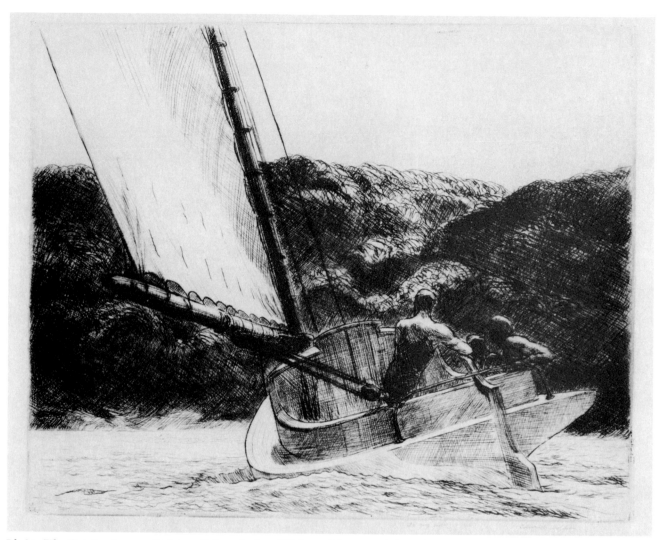

Pl. 83. *The Cat Boat*, 1922. Etching, 8 × 10 inches. Whitney Museum of American Art, New York; Bequest of Josephine N. Hopper 70.1008.

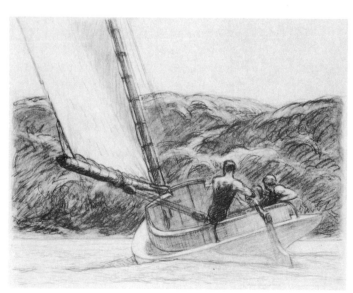

Pl. 84. Drawing for etching, *The Cat Boat*, 1922. Charcoal on paper, 10 × 13½ inches. Philadelphia Museum of Art: Purchased: The Harrison Fund.

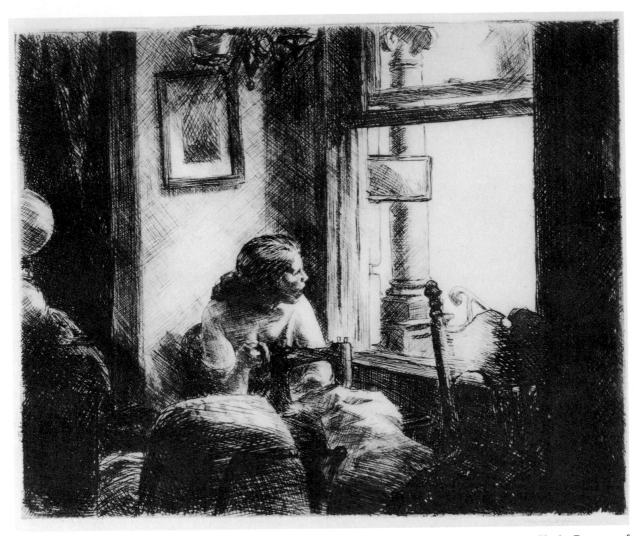

Pl. 85. *East Side Interior*, 1922. Etching, 8 × 10 inches. Whitney Museum of American Art, New York; Bequest of Josephine N. Hopper 70.1020.

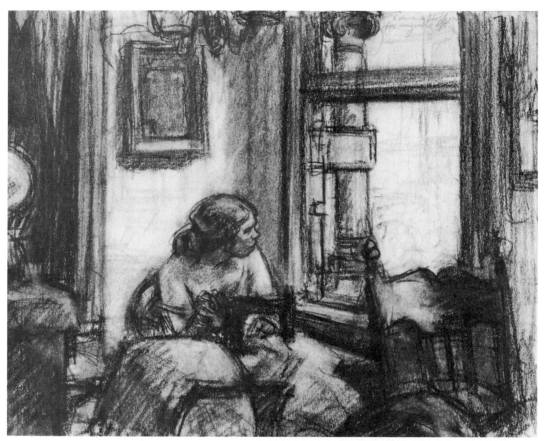

Pl. 86. Drawing for etching *East Side Interior*, 1922. Conte and charcoal on paper, 8¹⁵⁄₁₆ × 11½ inches. Whitney Museum of American Art, New York; Bequest of Josephine N. Hopper 70.342.

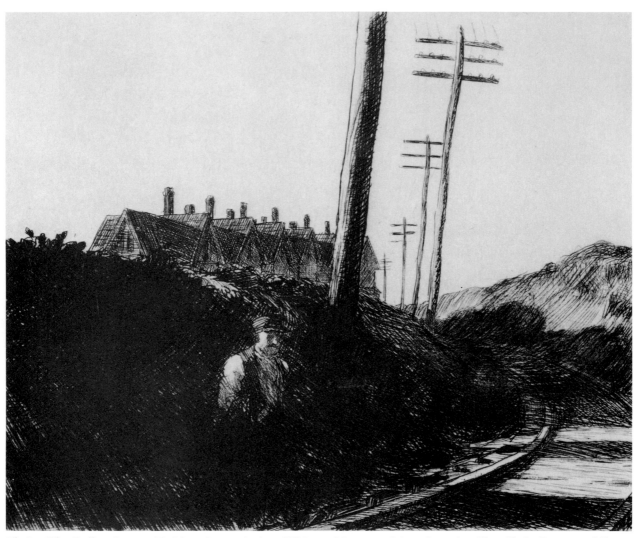

Pl. 87. *The Railroad,* 1922. Etching, 8 × 10 inches. Whitney Museum of American Art, New York; Bequest of Josephine N. Hopper 70.1049.

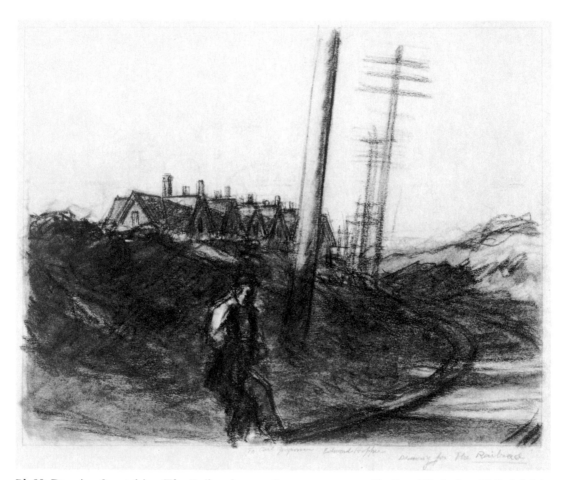

Pl. 88. Drawing for etching *The Railroad*, 1922. Conte on paper, 11 7/16 × 17 15/16 inches. Philadelphia Museum of Art: Purchased: The Harrison Fund.

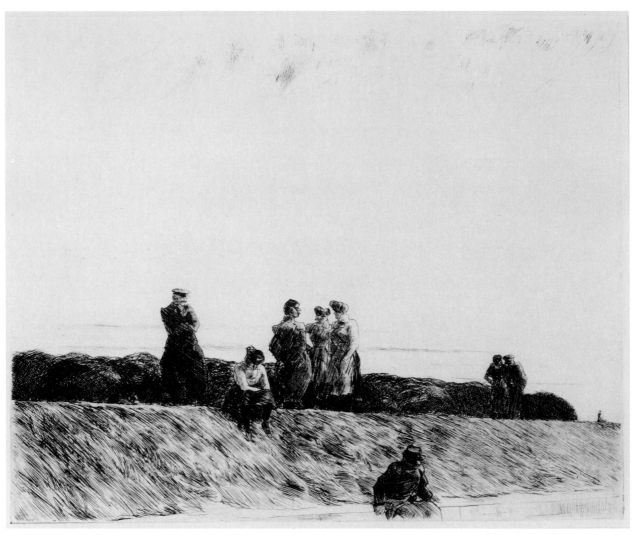

Pl. 89. *Aux Fortifications,* 1923, Etching, 12 × 15 inches. The Metropolitan Museum of Art, New York; Harris Brisbane Dick Fund, 1925.

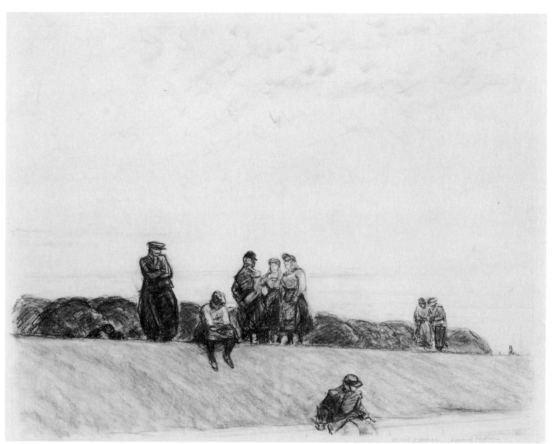

Pl. 90. Drawing for etching *Aux Fortifications,* 1923. Charcoal with pencil border on paper, 13¾ × 8½ inches. Philadelphia Museum of Art: Purchased: The Harrison Fund.

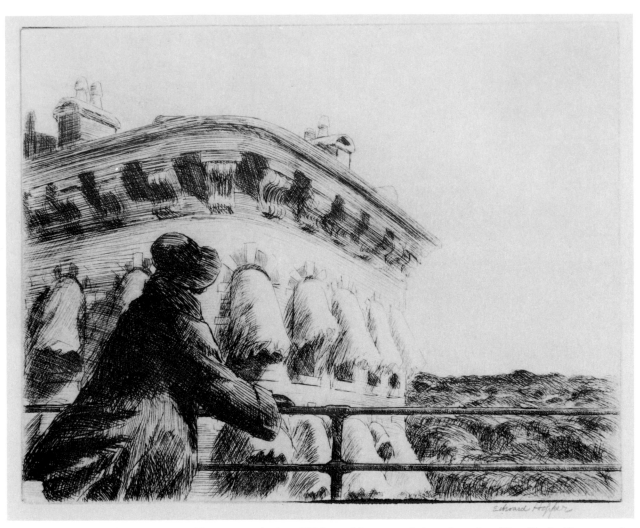

Pl. 91. *Girl on a Bridge,* 1923. Etching, 7 × 9 inches. Whitney Museum of American Art, New York; Bequest of Josephine N. Hopper 70.1023.

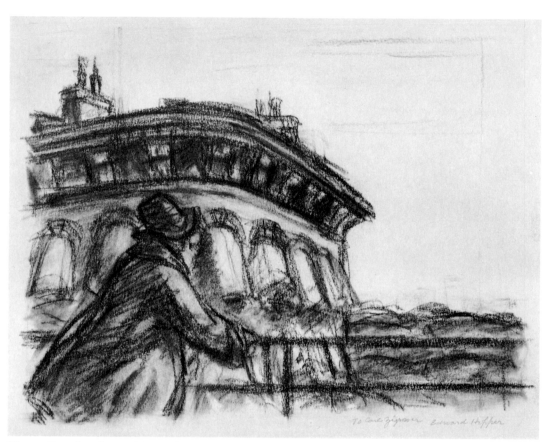

Pl. 92. Drawing for etching *Girl on a Bridge,* 1923, Conte on paper, 7 × 9¹⁄₁₆ inches. Philadelphia Museum of Art: Purchased: The Harrison Fund.

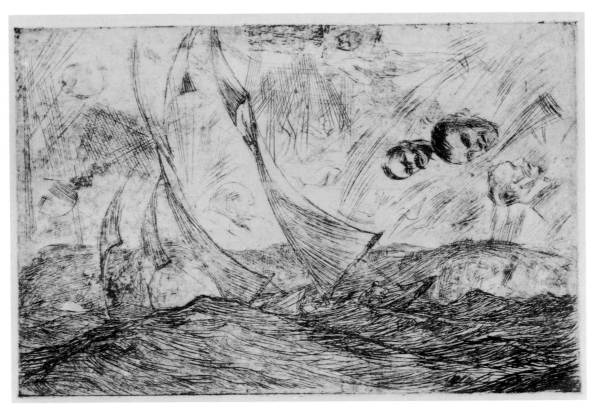

Pl. 93. [*Sailboat with Portrait Studies*], 1923. Etching with drypoint; plate, 6½ × 10 inches. Exists only in posthumous print. Whitney Museum of American Art, New York; plate, Bequest of Josephine N. Hopper.

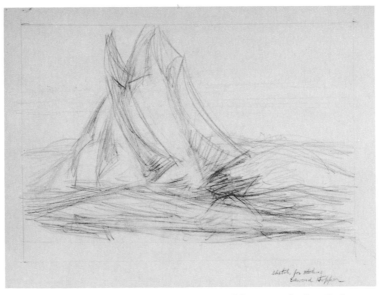

Pl. 94. Drawing for etching [*Sailboat with Portrait Studies*], 1923. Pencil on paper, 19⅜ × 11¹³⁄₁₆ inches. Whitney Museum of American Art, New York; Bequest of Josephine N. Hopper 70.994.

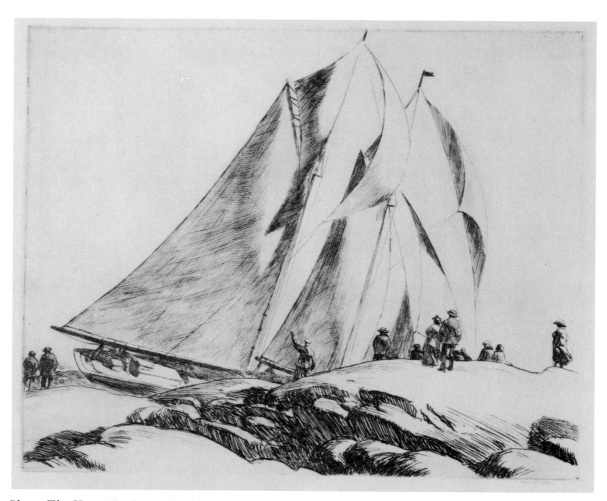

Pl. 95. *The Henry Ford,* 1923. Etching, 12 × 15 inches. The Art Institute of Chicago.

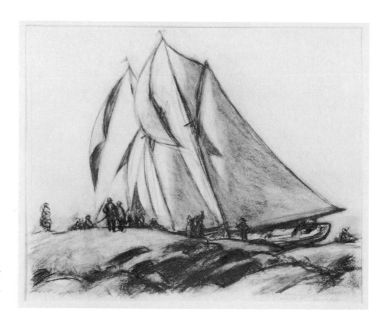

Pl. 96. Drawing for etching *The Henry Ford,* 1923. Conte and charcoal on paper, 15 × 18⅛ inches. Whitney Museum of American Art, New York; Bequest of Josephine N. Hopper 70.680.

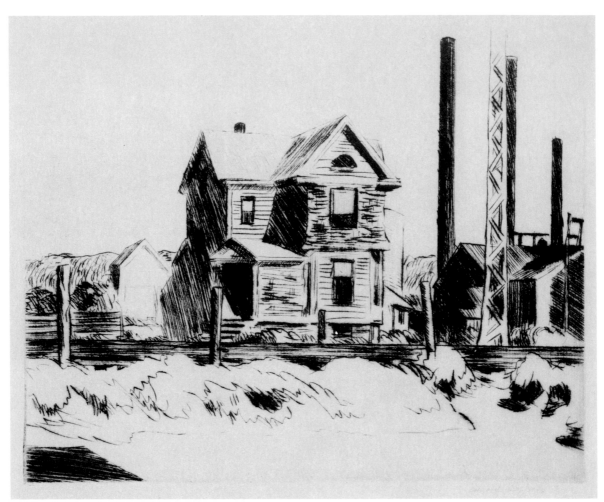

Pl. 97. *House at Tarrytown,* 1923. Drypoint, 8 × 10 inches. Whitney Museum of American Art, New York; Bequest of Josephine N. Hopper 70.1025.

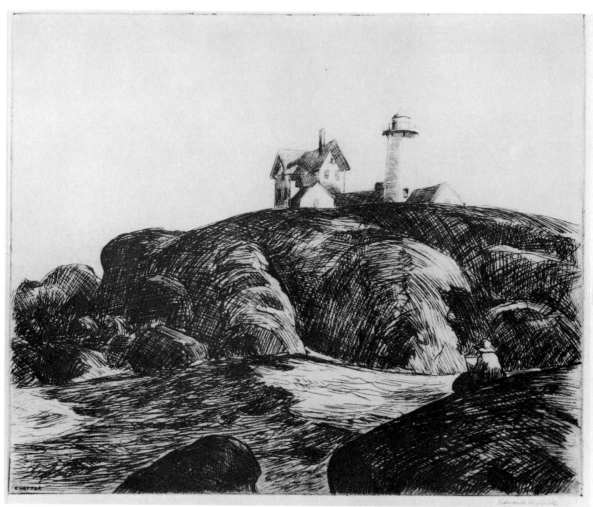

Pl. 98. *The Lighthouse* (sometimes called *Maine Coast*), 1923. Etching, 10 × 12 inches. Whitney Museum of American Art, New York; Bequest of Josephine N. Hopper 70.1032.

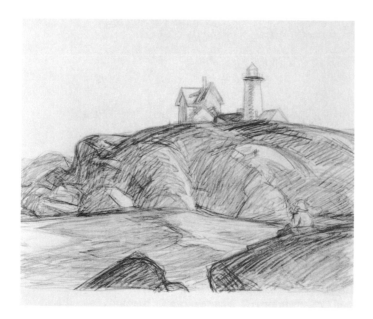

Pl. 99. Drawing for etching *The Lighthouse* (sometimes called *Maine Coast*), 1923. Pencil on paper, 10¼ × 12 inches. Kennedy Galleries, Inc., New York.

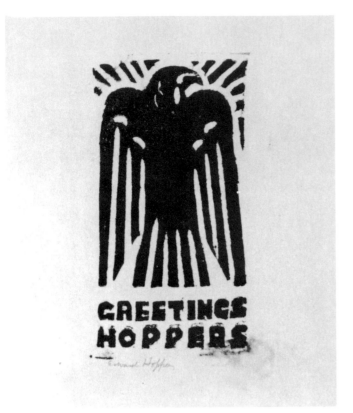

Pl. 104. *Greetings Hoppers* [*Eagle*], c. 1924–26. Linoleum cut, 8⅝ × 6¹¹⁄₁₆ inches. Private collection.

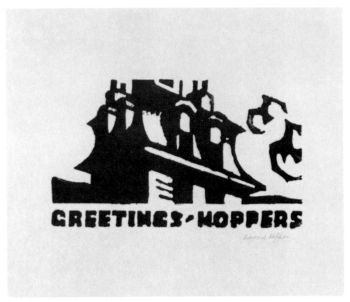

Pl. 105. *Greetings—Hoppers* [*House with Two Birds*], c. 1924–26. Linoleum cut, 6⅝ × 7¹¹⁄₁₆ inches. Private collection.

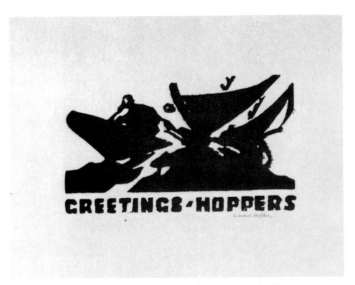

Pl. 106. *Greetings Hoppers* [*Sailing*], c. 1924–26. Linoleum cut, 5¼ × 8¾ inches. Private collection.

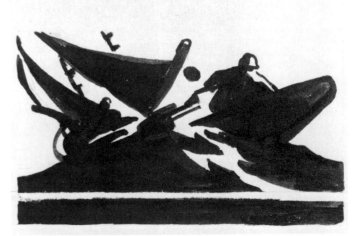

Pl. 107. *Study for Greeting Card*, c. 1924–26. Tempera on paper, 3¾ ×5½ inches. Private collection.

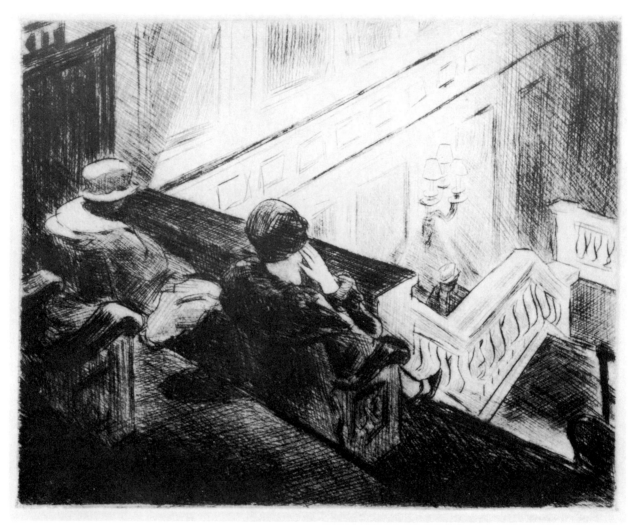

Pl. 108. *The Balcony* or *The Movies,* 1928. Drypoint, 8 × 10 inches. Whitney Museum of American Art, New York; Bequest of Josephine N. Hopper 70.1057.

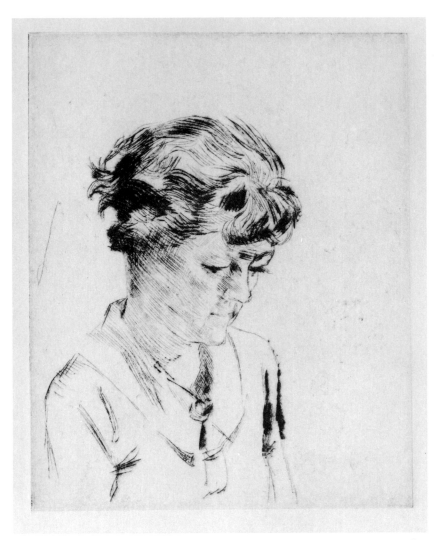

Pl. 109. *Portrait of Jo,* 1928. Drypoint; plate, 6⅞ × 5⁷⁄₁₆ inches. Exists only in posthumous print. Whitney Museum of American Art, New York; plate, Bequest of Josephine N. Hopper.

CHRONOLOGY

The information in this chronology has been compiled from the artist's ledgers and letters, various museum archives, exhibition catalogues, and published reviews. It attempts to give as complete an exhibition history as possible through 1928, the year Hopper made his last prints. Thereafter, only major retrospectives are listed. A complete chronology will follow in the catalogue raisonné.

1882 July 22, Edward Hopper born in Nyack, New York, son of Garrett Henry Hopper and Elizabeth Griffiths Smith Hopper. Attended local private school, graduated from Nyack High School.

1897 At the age of fifteen, built himself a catboat with wood provided by his father.

1899– Winter, studied illustration at the Correspondence
1900 School of Illustrating, a commercial art school in New York City at 114 West Thirty-fourth Street.

1900– New York School of Art, studied illustration with Arthur
1906 Keller and Frank Vincent DuMond, then painting under Robert Henri, William Merritt Chase, and Kenneth Hayes Miller. In class with Gifford Beal, George Bellows, Homer Boss, Patrick Henry Bruce, Arthur Cederquist, Clarence K. Chatterton, Glenn O. Coleman, Guy Pène du Bois, Arnold Friedman, Jules Golz, Jr., Rockwell Kent, Vachel Lindsay, Walter Pach, Eugene

Speicher, Carl Sprinchorn, Walter Tittle, and Clifton Webb. Along with Douglas John Connah and W. T. Benda, taught the Saturday class in drawing from life, painting, sketching, and composition at the New York School of Art.

1906 Employed as an illustrator by the C. C. Phillips agency, 24 East Twenty-second Street, New York.

 October, to Paris, lived at 48 rue de Lille in the building of the Église Évangélique Baptiste. Continued friendship with Patrick Henry Bruce in Paris.

1907 June 27, left Paris to travel to London where he visited the National Gallery, the Wallace Collection, and Westminster Abbey.

 July 19, left London for Holland. Visited Amsterdam and Haarlem where Robert Henri was conducting a summer school for American students. July 26, arrived in Berlin.

August 1, arrived in Brussels for two days before returning to Paris.

August 21, sailed for New York.

Worked as a commercial artist in New York.

1908 March 9–31, included in "Exhibition of Paintings and Drawings by Contemporary American Artists" at the old Harmonie Club building, 43–45 West Forty-second Street, New York; exhibited for the first time with several other Henri students; exhibited three oils, *The Louvre and the Seine*, *The Bridge of the Arts*, and *The Park at St. Cloud*, and one drawing, *Une Demimondaine*. The exhibition was organized by Arnold Friedman, Jules Golz, Jr., and Glenn O. Coleman. Also included were paintings by George Bellows, Guy Pène du Bois, Lawrence T. Dresser, Edward R. Keefe, Rockwell Kent, George McKay, Howard McLean, Carl Sprinchorn, and G. Leroy Williams.

1909 March 18, arrived in Paris via Cherbourg.

May, painted out-of-doors along the Seine frequently. Visited Fontainebleau.

June, visited St.-Germain-en-Laye.

July 31, sailed on Holland-America Line to New York, arriving on August 9.

1910 April 1–27, included in "Exhibition of Independent Artists," organized by John Sloan, Robert Henri, and Arthur B. Davies, at 29–31 West Thirty-fifth Street, New York; exhibited one oil, *The Louvre*.

Mid-May, returned to Paris. May 26, left Paris for Madrid. While in Spain, he visited Toledo and attended a bullfight. Returned to Paris on June 11.

July 1, sailed for New York.

After returning to New York, began to earn his living by commercial art and illustration; painted in free time and in the summers.

1912 February 22–March 5, included in "Exhibition of Paintings," The MacDowell Club of New York, at 108 West Fifty-fifth Street; exhibited five oils: *River Boat*, *Valley of the Seine*, *The Wine Shop*, *Sailing*, and *British Steamer*. Also included were paintings by George Bellows, Randall Davey, and Guy Pène du Bois.

Summer in Gloucester, Massachusetts, where he painted with Leon Kroll.

1913 January 9–21, included in "Exhibition of Paintings," The MacDowell Club of New York; exhibited two oils: *La Berge* and *Squam Light*.

February 15–March 15, included in the Armory Show (International Exhibition of Modern Art); exhibited one oil, *Sailing*, which sold for $250.

Moved to 3 Washington Square North, New York, where he lived until his death.

1914 January 22–February 1, included in "Exhibition of Paintings," The MacDowell Club of New York; exhibited two oils: *Gloucester Harbor* and *The Bridge*.

April 30–May 17, included in "Exhibition of Water Colors, Pastels, and Drawings by Four Groups of Artists," The MacDowell Club of New York; exhibited *On the Quai*, *Land of Fog*, *The Railroad*, *The Port*, and *Street in Paris*.

Summer in Ogunquit, Maine.

October 10–31, included in "Opening Exhibition, Season 1914–1915," at the Montross Gallery, 550 Fifth Avenue, New York; exhibited one oil, *Road in Maine*.

1915 Took up etching.

February 11–21, included in "Exhibition of Paintings," The MacDowell Club of New York; exhibited two oils: *Soir Bleu* and *New York Corner (Corner Saloon)*. Also included the paintings of George Bellows, John Sloan, Randall Davey, Eugene Speicher, and others.

Second summer in Ogunquit, Maine.

November 18–28, included in "Group Exhibition of Paintings," The MacDowell Club of New York; exhibited three oils: *American Village*, *Rocks and Houses*, and *The Dories*.

1916 February, eight of his Paris watercolor caricatures reproduced in *Arts and Decoration*.

Summer on Monhegan Island, Maine.

1917 February 15–25, included in "Exhibition of Paintings and Sculpture by Mary L. Alexander, George Bellows, A. Stirling Calder, Clarence K. Chatterton, Andrew Dasburg, Randall Davey, Robert Henri, Edward Hopper, Leon Kroll, Thalia W. Millett, Frank Osborn, John Sloan," at the MacDowell Club of New York; exhibited three oils: *Portrait of Mrs. Sullivan*, *Rocks and Sand*, and *Summer Street*.

April 10–May 6, included in the "First Annual Exhibition," American Society of Independent Artists; exhibited two oils: *American Village* and *Sea at Ogunquit*.

Summer on Monhegan Island, Maine.

1918 March 25–May 1, included in "An Exhibition of Etchings," Chicago Society of Etchers; exhibited *Somewhere in France*.

April 27–May 12, included in "Exhibition of Water Colors, Pastels, and Drawings by Four Groups of Artists," at the MacDowell Club of New York, along with Louis Burt, Clara M. Davey, Randall Davey, Benjamin Greenstein, Bernard Gussow, Robert Henri, Amy Londoner, Marjorie Organ, Louise de G. Rogers, John Sloan, Ruth Townsend, and others; exhibited eight etchings: *Bathers*, *The Monhegan Boat*, *Night on the El Train*, *Somewhere in France*, *Cow on Monhegan*, *The Bull Fight*, *The Open Window*, and *Evening, the Seine*.

Summer on Monhegan Island, Maine.

October, Hopper's poster *Smash the Hun,* which won the first prize in the "citizens" class nationwide competition of the National Service Section of the United States Shipping Board Emergency Fleet Corporation, was exhibited with those of nineteen other contestants in the window of Gimbel's department store on Broadway.

1919 Included in an exhibition of Red Cross posters at the Penguin Club, 8 East Fifteenth Street, New York, along with Max Weber, Arthur B. Davies, and others.

April 4–May 1, included in "An Exhibition of Etchings," Chicago Society of Etchers; exhibited *Open Window, The Bull Fight, The Monhegan Boat,* and *Bathers.*

1920 Through January 27, first one-artist exhibition, Whitney Studio Club, 147 West Fourth Street, New York; showed sixteen oils painted in Paris and in Monhegan, Maine: *Le Bistro, Le Pont des Arts, Le Pont-Neuf, Notre Dame de Paris, Juin, Après-midi de Printemps, Le Parc de St. Cloud, Le Quai des Grands Augustins, Le Louvre et la Seine, Les Lavoirs, Black Head, Monhegan, The Little Cove, Monhegan, Rocks and Houses, Squam Light, La Cité,* and *Road in Maine.*

Attended the Whitney Studio Club evening sketch class during the early and middle 1920s and made numerous life drawings.

February, included in an exhibition at the National Arts Club; exhibited *The Port, The Railroad,* and *Yankee Houses.*

March 9–April, included in "An Exhibition of Etchings," Chicago Society of Etchers, Art Institute of Chicago; exhibited *A Corner.*

March 30–April 30, included in "Works of Members," Whitney Studio Club; exhibited two etchings: *Bathers* and *The Bull Fight.*

August 28–September 11, included in "International Exhibition of Graphic and Applied Arts and Photography," Art Gallery of Ontario, Toronto; exhibited four etchings: *The Bull Fight, The Monhegan Boat, Cow and Rocks,* and *House by a River.*

October, showed in a group exhibition of drawings and prints at the Touchstone Galleries, New York, along with Robert Henri, George Bellows, Jerome Myers, Peggy Bacon, and Marjorie Organ; exhibited four etchings: *The Monhegan Boat, The Bull Fight, House by a River,* and *Cow and Rocks.*

November 29–December 17, included in the "Fifth Annual Exhibition of the Brooklyn Society of Etchers," at the Brooklyn Museum; exhibited two etchings: *Les Poilus* and *The Bull Fight.*

1921 January 25–February 28, included in "An Exhibition of Etchings," Chicago Society of Etchers; exhibited *Night Shadows.*

February 1–21, included in "Exhibition of the Brooklyn Society of Etchers," Brown–Robertson Galleries, New York; exhibited *Les Poilus* and *The Bull Fight.*

March 1–April 4, included in "Second International Printmakers Exhibition," Los Angeles County Museum; exhibited *Evening Wind.*

March 5–April 3, included in "Ninety-sixth Annual Exhibition," National Academy of Design, New York; exhibited three etchings: *Summer Twilight, Cow and Rocks,* and *The Bull Fight.*

March 20–April 20, included in "Annual Exhibition of Paintings and Sculpture by Members of the Club," Whitney Studio Club; exhibited one oil, *The Park Entrance.*

November 19–December 18, included in "Winter Exhibition," National Academy of Design; exhibited four etchings: *Evening Wind, Night Shadows, Night in the Park,* and *Train and Bathers.*

December 5–January 2, included in "Sixth Annual Exhibition of the Brooklyn Society of Etchers" at the Brooklyn Museum; exhibited two etchings: *Night in the Park* and *Soldier Reading.*

1922 January 26–February 28, included in "An Exhibition of Etchings," Chicago Society of Etchers; exhibited *Night in the Park.*

February, showed in "American Etchers Salon," at Brown–Robertson Galleries, New York; exhibited *Evening Wind.*

March 21–April 17, included in "Third International Print Makers Exhibition at the Los Angeles County Museum"; exhibited *Night in the Park.*

March 25–April 23, included in "Annual Exhibition of Paintings and Sculpture by Members of the Club," Whitney Studio Club; exhibited three etchings: *Night in the Park, Evening Wind,* and *House by a River;* and one oil, *New York Interior.*

April, Group Exhibition at the American Academy of Arts and Letters including Rockwell Kent, George Bellows, Mary Cassatt, and Arthur B. Davies; exhibited two etchings: *East Side Interior* and *American Landscape.*

April 14–August 26, included in an exhibition at the Cushing Memorial Gallery, Newport, Rhode Island; exhibited *East Side Interior.* Also included George Bellows, Randall Davey, Arthur B. Davies, and Rockwell Kent.

April 17–29, included in "First International Exhibition of Etching, Brooklyn Society of Etchers," at the Anderson Galleries; exhibited one etching, *Night Shadows.*

May, Group Exhibition of Village Artists, Greenwich House; exhibited *Night in the Park* and *Night on the El Train.*

May 4–31, showed in "Black and White Drawings by American Artists," at John Wanamaker, The Belmaison

Gallery, New York; exhibited two etchings: *Night Shadows* and *Night in the Park.*

October, exhibition of ten Paris watercolor caricatures at the Whitney Studio Club.

Included in "Twentieth Annual Water Color Exhibition and Twenty-First Annual Miniature Exhibition," Pennsylvania Academy of the Fine Arts, Philadelphia; exhibited three etchings: *East Side Interior, Evening Wind,* and *Night in the Park.*

November 17–December 17, included in "Winter Exhibition," National Academy of Design; exhibited four etchings: *The Lonely House, House by a River, Night on the El Train,* and *The Railroad.*

December 12–January 6, exhibited at the Wanamaker Gallery of Decorative Arts; exhibited *East Side Interior.*

December–January 1923, included in "Seventh Annual Exhibition of the Brooklyn Society of Etchers," at the Brooklyn Museum; exhibited two etchings: *East Side Interior* and *The Railroad.*

1923 February, included in "Etchings and Lithographs by Edward Hopper and Pop Hart," Sardeau Gallery, New York; exhibited two etchings, *East Side Interior* and *Evening Wind.*

February 1–March 11, included in "Exhibition of Etchings," Chicago Society of Etchers, The Art Institute of Chicago; exhibited two etchings: *East Side Interior* and *Evening Wind.* Hopper was awarded the Logan Prize of twenty-five dollars for the etching *East Side Interior.*

February 4–March 25, included in "118th Exhibition of Pennsylvania Academy of the Fine Arts," Philadelphia; exhibited one oil, *New York Restaurant.*

February, included in "National Arts Club, Humorist's Exhibition"; exhibited two Paris watercolor caricatures: *Le Militaire* and *Sargent de Ville.*

March, Salon of American Etching, Brown–Robertson Galleries, New York; exhibited one etching, *The Railroad.*

March 17–April 15, included in "Ninety-eighth Annual Exhibition," National Academy of Design, New York; exhibited three etchings: *The Lighthouse, Girl on a Bridge,* and *The Monhegan Boat;* and one drawing, *Yankee Houses.*

March–April, included in "Fourth International Printmakers Exhibition," Los Angeles County Museum; awarded William Alanson Bryan Prize for best American print, *East Side Interior.*

Made the last of his etchings. Summer in Gloucester, Massachusetts. Began to paint watercolors regularly.

April, "Second International Exhibition of Etching," Brooklyn Society of Etchers; exhibited two etchings: *American Landscape* and *Cow and Rocks.*

April 2–30, included in "Annual Exhibition of Paintings and Sculpture by Members of the Club," Whitney Studio Club; exhibited one oil, *La Berge.*

May 19–June 15, included in "Exhibition of Paintings, Watercolors, Drawings, Etchings, Lithographs, Photographs and Old Prints of New York City," at John Wanamaker, The Belmaison Gallery, New York; exhibited five etchings: *Night on the El Train, House Tops, Night Shadows, Central Park at Night* [*Night in the Park*], and *Lonely House, the Bronx* [*The Lonely House*].

June, "Prints of New York," views by Hopper and Bror Julius Olsson Nordfeldt at the Brown–Robertson Gallery, New York.

November 27–December 16, included in "Winter Exhibition," National Academy of Design, New York; exhibited three etchings: *The Locomotive, The Cat Boat,* and *Aux Fortifications.*

November 19–December 20, included in "A Group Exhibition of Watercolor Paintings, Pastels, Drawings, and Sculpture by American and European Artists," at the Brooklyn Museum; exhibited six watercolors: *Deck of a Beam Trawler, House with a Bay Window, The Mansard Roof, Beam Trawler Seal, Shacks at Lanesville,* and *Italian Quarter, Gloucester.*

December–January 1924, included in "Eighth Annual Exhibition of Brooklyn Society of Etchers," at the Brooklyn Museum; exhibited four etchings: *The Evening Wind, Les Deux Pigeons, The Cat Boat,* and *Aux Fortifications.*

December 12–January 27, 1924, included in "Exhibition of Contemporary American Watercolors," Cleveland Museum of Art; exhibited *New England House* and *Dead Tree.*

December 16–January 20, 1924, included in "Ninth Biennial Exhibition of Contemporary American Oil Paintings," Corcoran Gallery of Art, Washington, D.C.; exhibited one oil, *New York Restaurant.*

December 7, 1923, the Brooklyn Museum purchased *The Mansard Roof* for $100.

1924 February 1–March 11, included in "An Exhibition of Etchings," Chicago Society of Etchers; exhibited *The Cat Boat* and *Aux Fortifications.*

February 3–March 23, included in "119th Annual Exhibition," Pennsylvania Academy of the Fine Arts, Philadelphia; exhibited one oil, *New York Interior.*

February, included in "Lithographs and Etchings," Whitney Studio Galleries, 8 West Eighth Street, New York, along with George Bellows, Georges Braque, Paul Cézanne, Honoré Daumier, Edgar Degas, Eugène Delacroix, André Derain, Jean Auguste Dominique Ingres, Rockwell Kent, Walt Kuhn, Edouard Manet, Henri

Matisse, Pablo Picasso, Boardman Robinson, and Charles Sheeler; exhibited two etchings: *Night in the Park* and *Night Shadows*.

March 20–April 22, exhibited in "Fourth International Water Color Exhibition," Art Institute of Chicago; included four watercolors: *Deck of a Beam Trawler, Houses of Squam Light, Beam Trawler Seal,* and *Italian Quarter, Gloucester*.

April 15, included in exhibition at the Belmaison Gallery, New York; exhibited *New York Corner (Corner Saloon)*.

May 1–25, included in "Annual Members Exhibition," Whitney Studio Club; exhibited one oil, *New York Restaurant*.

Married Josephine Verstille Nivison on July 9, 1924, at the Église Evangélique on West Sixteenth Street, New York. Guy Pène du Bois was Hopper's best man.

Summer in Gloucester, Massachusetts.

November, Frank K. M. Rehn Gallery, New York, held exhibition of recent watercolors. All eleven shown and five additional ones were sold. The exhibition was a success, enabling Hopper to give up commercial work and illustration. (His illustrations were published in *Scribner's* through 1927).

November 9–December 14, included in "Twenty-second Annual Water Color and Twenty-third Annual Miniature Exhibition," Pennsylvania Academy of the Fine Arts, Philadelphia; exhibited one etching, *Night on the El Train*.

December–January 1925, included in "Ninth Annual Exhibition of the Brooklyn Society of Etchers," at the Brooklyn Museum; exhibited four etchings: *Girl on a Bridge, The Monhegan Boat, Maine Coast,* and *The Locomotive*.

1925 January 15–February 15, included in "Second Annual Exhibition of Watercolors and Pastels," Cleveland Museum of Art; exhibited *School Yard*.

February 8–March 29, included in "120th Exhibition of the Pennsylvania Academy of the Fine Arts"; exhibited one oil, *Apartment Houses*.

February 24, included in "Drawings, Lithographs, Etchings, and Woodcuts," Whitney Studio Club; exhibited two etchings: *Evening Wind* and *Night in the Park*.

April 13–25, included in "Fourth International Etching Exhibition" (under the auspices of Brooklyn Society of Etchers), at the Anderson Galleries, New York; exhibited *Aux Fortifications*.

May, included in "Annual Exhibition of Recent Accessions," New York Public Library.

May 1–June 4, included in "Fifth International Water Color Exhibition," Art Institute of Chicago; exhibited one watercolor, *School Yard*.

May 18–May 30, included in "Tenth Annual Exhibition," Whitney Studio Club at the Anderson Galleries; exhibited two oils: *Yonkers* and *New York Corner*.

Spring, included in an exhibition of the New Gallery; exhibited one watercolor, *Dead Trees*.

June through late September, visited James Mountain, Colorado, and Santa Fe, New Mexico, where he painted seven watercolors.

June 12–July 12, included in "Fifth Annual Exhibition of Contemporary American Paintings," Cleveland Museum of Art; exhibited one oil, *New York Restaurant*.

October, included in "Fifth Annual Exhibition of the Art Alliance," Art Centre, New York.

October 29–December 13, "Thirty-eighth Annual Exhibition of American Paintings and Sculpture," Art Institute of Chicago; exhibited one oil, *New York Restaurant*.

November, included in "Tenth Annual Exhibition," of the Brooklyn Society of Etchers at the Brooklyn Museum; exhibited three etchings: *Night on the El Train, The Bay Window,* and *House Tops*.

November 20, 1925–January 3, 1926, included in "Paintings in Oil by American and European Artists," The Brooklyn Museum; exhibited *The Bootleggers*.

December 8, 1925–January 4, 1926, included in "Exhibition of Watercolors by Distinguished American Artists," MacBeth Gallery, New York; exhibited two watercolors: *Dead Trees* and *Near Santa Fe*.

1926 January 6–30, included in "The New Society of Artists Exhibition," The Anderson Galleries, New York; exhibited two oils: *House by the Railroad* and *New York Pavements*.

January 14–February 15, included in "Third Annual Exhibition of Watercolors and Pastels," Cleveland Museum of Art; exhibited *Poplars, Santa Fe,* and *Manhattan Bridge*.

January 26–February 15, included in "Exhibition of Tri-National Art"; exhibited in Paris, London, then to Wildenstein Galleries in New York City (then to Germany); exhibited one oil, *The Bootleggers*.

February 17–March 6, included in an exhibition at the Boston Art Club; exhibited five oils: *The Louvre, Le Pont des Arts, Le Quai des Grands Augustins, Ecluse de la Monnaie,* and *Notre Dame de Paris*.

February, included in "Today in American Art," Frank K. M. Rehn Gallery; exhibited one oil, *Sunday*.

March 8–March 20, included in "Eleventh Annual Exhibition of Paintings and Sculpture by Members of the Club," Whitney Studio Club at the Anderson Galleries; exhibited one etching, *Aux Fortifications*.

April 7–18, included in an exhibition of Village Artists at Greenwich House; exhibited four etchings: *Night*

Shadows, Evening Wind, Night in the Park, and *East Side Interior;* and one oil, *Summer Street.*

April 13–May 1, "Exhibition of Water Colors and Etchings by Edward Hopper," St. Botolph Club, Boston; exhibited twenty-one prints and nineteen watercolors.

Took train trip to Eastport, Maine, for several days, then to Bangor.

Traveled by boat to Rockland, Maine, for seven weeks, then on to Gloucester, Massachusetts.

June, "Thirty-third Annual Exhibition of American Art," Cincinnati Art Museum; exhibited two etchings: *East Side Interior* and *House Tops.*

1927　February 17–March 13, "Fourth Exhibition of Watercolors and Pastels," Cleveland Museum of Art; exhibited *Shipyard, Rockland, Self-Portrait,* and *Gloucester Harbor.*

May 28–July 31, included in "Thirty-fourth Annual Exhibition of Contemporary American Paintings," Cleveland Museum of Art; exhibited one oil, *Gloucester Street.*

Purchase of automobile.

Summer at Two Lights, Cape Elizabeth, Maine. Visited Mrs. Summer at Two Lights. Visited Mrs. Catherine Budd in Charlestown, New Hampshire, on return trip. Made an excursion across the Connecticut River into Vermont.

December 10–31, included in "Exhibition of Etchings, Lithographs, and Woodcuts by Thirty-six Members," American Printmakers Society, Downtown Gallery, New York; exhibited four etchings: *The Locomotive, The Cat Boat, Night Shadows,* and *Night in the Park.*

1928　January 5–February 5, included in "The Museum's Collection of Water Colors by American Artists," Fogg Art Museum, Cambridge.

January 15, made drypoint *The Balcony* or *The Movies.*

January 18–February 1, included in "Loan Exhibition of Distinguished Works of Art," Wadsworth Atheneum, Hartford; exhibited one watercolor, *Captain Strout's House.*

January 20, made his last print, a drypoint, *Portrait of Jo.*

February–May, included in "Tri-Unit Exhibition of Paintings and Sculpture," Phillips Memorial Gallery, Washington, D.C.; exhibited one oil, *Sunday.*

March 7–April 10, included in "Fifth Exhibition of Watercolors and Pastels," Cleveland Museum of Art; exhibited *Civil War Camp Ground* and *Tug Boat.*

April 29–May 26, included in "Thirteenth Annual Exhibition of Paintings and Sculpture by Members of the Club," The Whitney Studio Club, at the Whitney Galleries; exhibited one oil, *Eleven A.M.*

April 29–June 24, included in "Twenty-second Annual Exhibition of Selected Paintings by American Artists," Buffalo Fine Arts Academy, Albright Art Gallery; exhibited one oil, *The Bootleggers.*

May, "Exhibition of Watercolors by Seventeen Americans," Phillips Memorial Gallery; exhibited one watercolor, *St. Francis' Towers, Santa Fe.*

May 26–July 31, included in "Thirty-fifth Annual Exhibition of American Art," Cincinnati Art Museum; exhibited one etching, *Girl on a Bridge.*

Summer in Gloucester, Massachusetts. Trip to Ogunquit, Maine, to visit Clarence K. and Annette Chatterton of Vassar. Traveled through New Hampshire and Vermont before returning to New York.

June 8–July 8, included in "Eighth Annual Exhibition of Contemporary American Paintings," Cleveland Museum of Art; exhibited one oil, *Captain Upton's House.*

October, included in "Exhibition of American Watercolors: Homer, Sargent, Hopper, Hopkinson, MacKnight," Fogg Art Museum, Cambridge.

October 1–30, included in "American Printmakers Exhibition," Institute of Arts, Detroit; exhibited four etchings: *The Locomotive, The Cat Boat, Night Shadows,* and *Night in the Park.*

October 18–December 9, included in "Twenty-seventh Annual International Exhibition of Paintings," Carnegie Institute, Pittsburgh; exhibited three oils: *Eleven A.M., Two on the Aisle,* and *Gloucester Street.*

October 25–December 16, included in "Forty-first Annual Exhibition of American Painting and Sculpture," The Art Institute of Chicago; exhibited one oil, *New York Pavements.*

October 28–December 9, included in "Eleventh Biennial Exhibition of Contemporary American Oil Paintings," Corcoran Gallery of Art, Washington, D.C.; exhibited one watercolor, *Captain Upton's House.*

November–December, included in "Exhibition of Paintings Lent by Phillips Memorial Gallery, Washington," Toronto Art Gallery; exhibited one oil, *Sunday.*

November 25–December 9, exhibition "Watercolors of Edward Hopper," including twelve watercolors at the Morgan Memorial (now the Wadsworth Atheneum) in Hartford, Connecticut.

December, included in "Second Annual Exhibition of American Printmakers," The Downtown Gallery, New York; exhibited four etchings: *The Lonely House, East Side Interior, Night in the Park,* and *American Landscape.*

1929　January 21–February 2, one-artist exhibition at Frank K. M. Rehn Gallery of twelve oils, ten watercolors, and a group of drawings.

April 1–May 11, trip to Charleston, South Carolina.

Summer, visit to Topsfield, Massachusetts, home of Mr. and Mrs. Samuel A. Tucker. Second stay at Two Lights, Cape Elizabeth, Maine. Trips to Essex and Pemaquid Point.

1930 Visited with Edward and Grace Root at Hamilton College, Clinton, New York, before going to South Truro, Massachusetts, on Cape Cod. Rented A. B. Cobb's house, "Bird Cage Cottage," on a hill.

1931 Honorable Mention and cash award, First Baltimore Pan-American Exhibition.

1931– Summers in "Bird Cage Cottage" in South Truro,
1932 Massachusetts.

1932 March, elected an associate member of the National Academy of Design, which he declined as they had rejected his paintings in years past. Took additional studio space at 3 Washington Square North, New York.

November–January 5, 1933, included in the first Whitney Museum of American Art Biennial (and in almost every later Whitney Biennial and Annual).

1933 Trip to Murray Bay, Quebec Province, Canada, then visited Ogunquit and Two Lights, Maine, and Boston. Returned to South Truro, Massachusetts, to "Bird Cage Cottage."

October 1, purchased land in South Truro and returned to New York later that month.

November 1–December 7, Retrospective Exhibition at the Museum of Modern Art, New York; exhibited twenty-five oils, thirty-seven watercolors, and eleven prints.

1934 January 2–16, Retrospective at the Arts Club of Chicago.

Early May, went to South Truro. While building studio house at South Truro, Massachusetts (in which they spent every successive summer except where noted), the Hoppers stayed at the Jenners' house. The house was completed on July 9, and they remained through late November.

1935 Awarded Temple Gold Medal, Pennsylvania Academy of the Fine Arts, and First Purchase Prize in watercolor, Worcester Art Museum.

Trip from Truro to East Montpelier, Vermont.

1936 Visited Plainsfield, Vermont.

1937 Awarded First W. A. Clark Prize and Corcoran Gold Medal, Corcoran Gallery of Art.

September, visited South Royalton (White River Valley), Vermont.

1938 September, visit to South Royalton (White River Valley), Vermont, during hurricane. Stayed in Truro, Massachusetts, through late November.

Acquired rear studio at 3 Washington Square North for Jo Hopper.

1939 Returned to New York early from summer at Truro in order to travel to Pittsburgh, Pennsylvania, to be on the jury of the Carnegie Institute. Painted no watercolors this year or next, but painted oils in Truro studio.

1940 Traveled from Truro to New York to register to vote. Returned to New York early from the cape in order to vote for Wendell Willkie against Franklin Roosevelt.

1941 Spring, trip to Albany to jury exhibition.

Summer (May through July), traveled to the West Coast by car. Visited Colorado and Utah. Drove through Nevada desert to Pacific Coast and north through California to Oregon Coast. Returned via Wyoming and Yellowstone Park. Returned to house at Truro late in August.

1942 Awarded Ada S. Garrett Prize, The Art Institute of Chicago.

1943 March, traveled to Washington to be on the Corcoran jury.

Summer, having no gas to travel to Cape God, made first trip to Mexico by train. Visited Mexico City, Saltillo, and Monterey, returning in early October. Painted four watercolors from roof of Guarhado House, Saltillo, and two from window of Monterey Hotel.

1944 South Truro. Trips to Boston and Hyannis for automobile repairs.

1945 Awarded Logan Art Institute Medal and Honorarium, The Art Institute of Chicago.

May, elected member of the National Institute of Arts and Letters.

1946 Awarded Honorable Mention, The Art Institute of Chicago.

May, drove to Saltillo, Mexico. Painted four watercolors. July in Grand Tetons; August through November in South Truro.

1947 November, trip to Indianapolis to serve on jury of Indiana artists exhibition.

1950 February 11–March 26, Retrospective Exhibition at the Whitney Museum of American Art; exhibition shown at the Museum of Fine Arts, Boston, in April, and the Detroit Institute of Arts in June. Awarded honorary degree, Doctor of Fine Arts, by the Art Institute of Chicago. Hopper attended the openings in Boston and Detroit and received his degree in Chicago.

1951 May 28, left by car for third trip to Mexico via Chattanooga, Tennessee. In Saltillo for a month. Visited Santa Fe, New Mexico, briefly on returning. Stayed in South Truro until November.

1952 Hopper was one of the four artists chosen by the American Federation of Arts to represent the United States in the Venice Biennale.

Summer in South Truro.

December, left for Mexico. Stayed eight days in El Paso, Texas. Visited Posada de la Presa, Guanajuato, and spent one month at Mitla, Oaxaca. Visited Puebla and returned via Laredo.

1953 March 1, returned to New York from Mexico, where he painted two watercolors.

Joined Raphael Soyer and other representational painters in publishing *Reality* (on editorial committee).

June, honorary degree, Doctor of Letters, Rutgers University.

July, South Truro. September 15, to Gloucester and on to Charlestown, New Hampshire, to visit Mrs. William Proctor.

1954 Awarded First Prize for Watercolor, Butler Art Institute.

1955 March 31, left for Mexico through May 1. Summer and fall in South Truro.

Gold Medal for Painting presented by the National Institute of Arts and Letters in the name of the American Academy of Arts and Letters.

1956 Awarded Huntington Hartford Foundation fellowship.

December 9, arrived at Huntington Hartford Foundation, Pacific Palisades, California.

1957 June 6, left Huntington Hartford Foundation.

July 22 through late October in South Truro.

Received New York Board of Trade's Salute to the Arts award, and First Prize, Fourth International Hallmark Art Award.

1959 July 15, to South Truro for summer.

October trip to Manchester, New Hampshire, for November one-artist exhibition at Currier Gallery of Art.

December, this exhibition shown at Rhode Island School of Design. Visited Providence, Rhode Island, as the guests of Mr. and Mrs. Malcolm Chace.

1960 January, exhibition at Wadsworth Atheneum, Hartford, Connecticut.

Received Art in America Annual Award.

Spring, met with the artists' group who had published *Reality* at home of John Koch to protest the predominance of the "gobbledegook influences" of abstract art at the Whitney Museum and at the Museum of Modern Art.

1962 October–November, "The Complete Graphic Work of Edward Hopper," Philadelphia Museum of Art; included fifty-two prints; publication of a catalogue raisonné; later went to Worcester Art Museum.

1963 Received award from the St. Botolph Club, Boston. Retrospective Exhibition at the Arizona Art Gallery. July 4 through late November, in South Truro.

1964 May, illness kept Hopper from painting.

Awarded M. V. Khonstamn Prize for Painting, The Art Institute of Chicago.

September 29–November 29, major Retrospective Exhibition at the Whitney Museum of American Art; shown from December (through January 1965) at the Art Institute of Chicago.

1965 February 18–March 21, Retrospective shown at the Detroit Institute of Arts and April 7–May 9 at the City Art Museum of St. Louis.

Awarded honorary degree, Doctor of Fine Arts, Philadelphia College of Art.

July 16, death of Hopper's sister Marion in Nyack, New York.

Last painting, *Two Comedians.*

1966 Awarded Edward MacDowell Medal.

1967 May 15, Edward Hopper died in his studio at 3 Washington Square North.

September 22–January 8, 1968, Hopper's work was featured in the United States Exhibition at the Bienal de São Paulo 9.

Edward Hopper in his New York studio, 1955. Photograph by Sidney Waintrob, Budd Studio.

SELECTED BIBLIOGRAPHY

Barr, Alfred H., Jr. *Edward Hopper: Retrospective Exhibition.* New York: Museum of Modern Art, 1933.

Barker, Virgil. "The Etchings of Edward Hopper." *The Arts,* 5 (June 1924), pp. 322–27.

Burke, James. *Charles Meryon Prints and Drawings.* New Haven: Yale University Art Gallery, 1974.

Burrey, Suzanne. "Edward Hopper: The Emptying Spaces." *Arts Digest,* 1 April 1955, pp. 8–10, 33.

Deltail, Loys. *Meryon.* Masters of Modern Art Scenes. New York: Dodd, Mead, 1928.

du Bois, Guy Pène. "Edward Hopper, Draughtsman." *Shadowland,* 7 (October 1922), pp. 22–23.

Eichenberg, Fritz. *The Art of the Print: Masterpieces, History, Techniques.* New York: Harry N. Abrams, 1976.

Eitner, Lorenz. "The Open Window and the Storm-Tossed Boat." *Art Bulletin,* 37 (December 1955), pp. 281–90.

Getlein, Frank. "The Legacy of Edward Hopper, Painter of Light and Loneliness." *Smithsonian,* 2 (September 1971), pp. 60–67.

Goodrich, Lloyd. *Edward Hopper.* Harmondsworth, England: Penguin Books, 1949.

———. *Edward Hopper Retrospective Exhibition.* New York: Whitney Museum of American Art, 1950.

———. *Edward Hopper, Exhibition and Catalogue.* New York: Whitney Museum of American Art, 1964.

———. *Edward Hopper.* New York: Harry N. Abrams, 1971.

———. *Edward Hopper: Selections from the Hopper Bequest to the Whitney Museum of American Art.* New York: Whitney Museum of American Art, 1971.

Hopper, Edward. Collected correspondence. Whitney Museum of American Art, New York.

———. In "Books" (review of Malcolm C. Salaman, *Fine Prints of the Year, 1925.* London: Holton and Truscott Smith; and New York: Minton, Balch, 1926). *The Arts,* 9 (March 1926), pp. 172–74.

———. "John Sloan and the Philadelphians." *The Arts,* 11 (April 1927), p. 174.

Karshan, D. H. "American Printmaking, 1670–1968." *Art in America,* 56 (July–August 1968), pp. 22–55.

Kuh, Katharine. *The Artist's Voice: Talks with Seventeen Artists.* New York: Harper and Row, 1962.

Laver, James. *A History of British and American Etching.* New York: Dodd, Mead, 1929.

Levin, Gail. "Edward Hopper's 'Office at Night.'" *Arts Magazine,* 52 (January 1978), pp. 134–37.

———. "Edward Hopper: Francophile." *Arts Magazine,* 53 (June 1979), pp. 114–21.

McCarron, Paul. *Martin Lewis: The Graphic Work.* New York: Kennedy Galleries, 1973.

O'Doherty, Brian. *American Masters: The Voice and the Myth.* New York: Random House, 1973.

Read, Helen Appleton. *Robert Henri and Five of his Pupils:*

George Bellows, Eugene Speicher, Guy Pène du Bois, Rockwell Kent, Edward Hopper. Exhibition catalogue. New York: Century Association, 1946.

Reece, Childe. "Edward Hopper's Etchings." *Magazine of Art,* 31 (April 1938), pp. 226–28.

Rodman, Selden. *Conversations with Artists.* 1957; reprinted, New York: Capricorn Books, 1961.

Tittle, Walter. "The Pursuit of Happiness" (unpublished autobiography). Wittenberg University Library, Springfield, Ohio.

Zigrosser, Carl. "The Etchings of Edward Hopper." In *Prints,* edited by Carl Zigrosser. New York: Holt, Rinehart, and Winston, 1962.

PHOTOGRAPHIC CREDITS

Photographs have been supplied in most cases by the owners or custodians of the works, as cited in the captions. The following list applies to photographs, indicated by plate and figure number, for which additional acknowledgment is due.